Martin, Christmas '14

BLAM!!

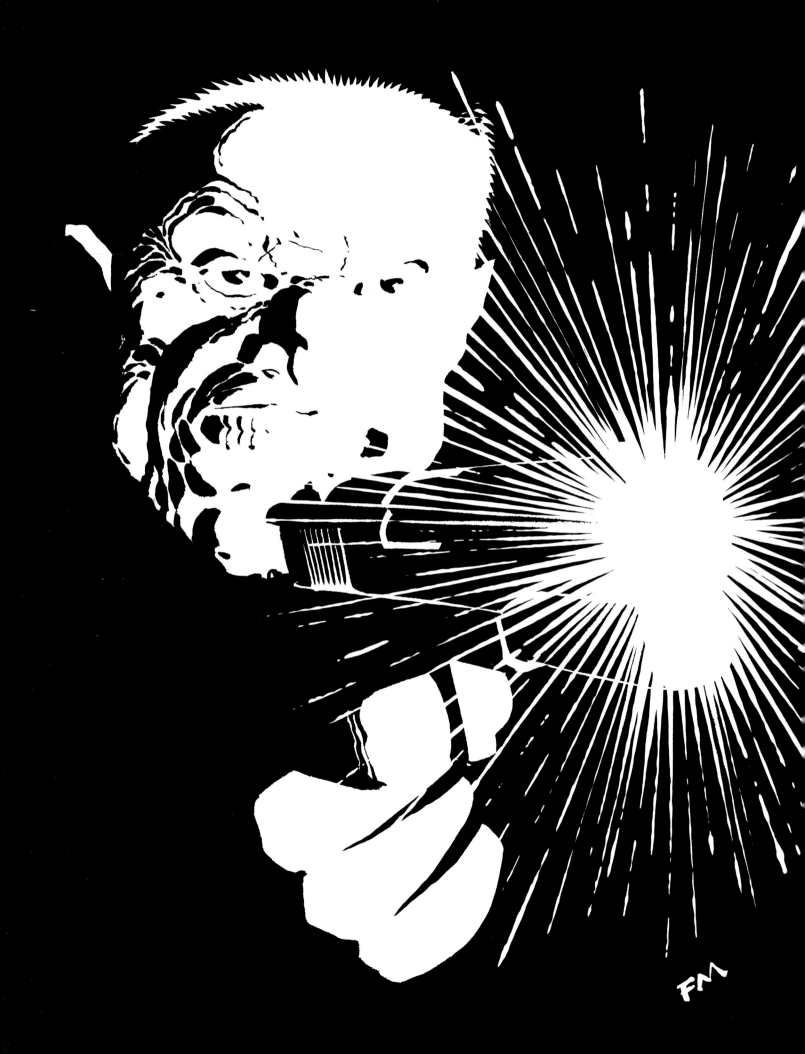

FRANK MILLER

THE ART OF

SIN CITY®

...PANSIES.

KHEFF

Editor
DIANA SCHUTZ

Assistant Editor
AARON WALKER

Design & Production
CARY GRAZZINI

Publisher
MIKE RICHARDSON

FRANK MILLER: THE ART OF SIN CITY
Copyright © 1991-2002, 2014 Frank Miller, Inc.
All rights reserved. Sin City, the Sin City logo,
and all characters featured herein and the
distinctive likenesses thereof and all related
elements are trademarks of Frank Miller, Inc.
No portion of this book may be reproduced
or transmitted, in any form or by any means,
without the express written permission of
Frank Miller, Inc. The stories, characters,
institutions, and incidents portrayed herein
are fictional. Any resemblance to actual
persons (living or dead), events, institutions,
or locales, without satiric intent, is
coincidental. Dark Horse Books and the Dark
Horse logo are registered trademarks of Dark
Horse Comics, Inc. All rights reserved.

This volume was originally published in
hardcover, with minor differences, in 2002.

Published by Dark Horse Books
A division of Dark Horse Comics, Inc.
10956 SE Main Street
Milwaukie, Oregon 97222

DarkHorse.com

First edition: July 2014
ISBN 978-1-61655-247-3

10 9 8 7 6 5 4 3 2 1
Printed in China

WHEN LESS IS MORE, AN ENTIRE CITY

AN INTRODUCTION BY R.C. HARVEY

The medium of the comics is a visual medium. Or so we've often heard. And I've even said it occasionally. To say that comics is a visual medium is to deploy verbal shorthand to make the point that pictures play a dominant role in comics storytelling. And that is true. But it is only a half-truth. Comics use words as well as pictures, and in the best comics, the verbal and the visual blend to create a meaning that neither words nor pictures alone without the other achieve. Despite this seemingly equal yoking, pictures predominate: they identify the medium. In shorthand or longhand, they set comics stories apart from prose narratives. They also enhance the drama inherent in any story by pacing events and focusing attention. No one knows this any better than Frank Miller.

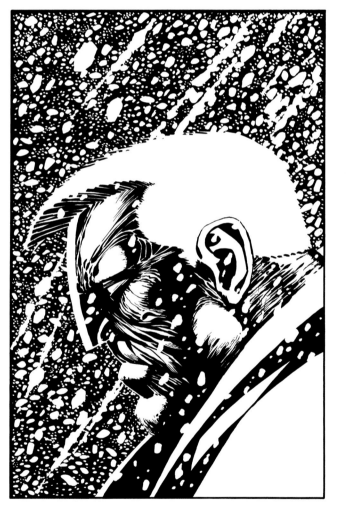

Miller edged over the horizon into national awareness of his work in 1979 when he was assigned to one of Marvel's slow-movers, *Daredevil*, written by Roger McKenzie. It was the era of the relentlessly chatty caption in every title. Miller managed, almost from the start, to prune the language, relying more and more upon pictures to carry the narrative forward and to create tone and drama. After about ten issues, McKenzie was gone, and Miller was in full control of words as well as pictures, fabricating plot as well as mood. It was an extraordinary period in Miller's development as a cartoonist (who, by definition, creates in visual-verbal terms) and in the maturation of the art form. Devouring the work of such comics masters as Harvey Kurtzman and Will Eisner, Miller put what he learned from them to work as soon as he'd learned the lesson. In an electrifying display of virtuosity, he seemed to move immediately, almost instantaneously, from mimicry to mastery: he understood a technique that he observed so thoroughly that he seemed wholly in command of it the first time he employed it. And every device he used, he improved upon. He varied page layouts and panel composition to heighten the drama of events with visual emphasis; he used wordless sequences of nearly static imagery to promote emotional impact; he paced his narrative, dribbling out elements of plot piecemeal, panel by panel for pages, building suspense. He even had pages on which white space was the prevailing image, austerely accenting the strategically arrayed pictures. In Miller's hands, *Daredevil* became a best seller. And so did Frank Miller. From about this time henceforth, he was able to pick and choose his projects with a freedom not often accorded comic book creators. Ultimately, Miller chose crime.

The underworld, cops and robbers (with an emphasis on bad guys and the frailty of human nature in an urban jungle), has been Miller's favored milieu all along. During his apprenticeship on Marvel titles, he tolerated the squads of superheroes in their spangled spandex. But he is enamored of the storytelling possibilities inherent in lawlessness. Understandably, Miller's *Daredevil* had eased pretty soon into a seedy Hell's Kitchen of petty crooks and criminal degenerates, the portrait of life on the edge of the law tinged with shadowy refuse-choked alleyways and the litter on saloon floors sticky with spilled booze and pockmarked by stubbed-out cigarette butts. In Miller's epochal *Dark Knight* series for DC Comics in 1986, the iconic Batman moved into the same neighborhood, and when he came out, he was psychically scarred, perhaps forever. This leader of the longjohn legions

had been so corrupted by his encounter with gritty criminality that he would never again be the same as he was before. And neither, so persuasive is Miller's influence, would many of Batman's cohorts in crime-fighting, all of whom, in one way or another, seemed to sip a little from the same bitter brew that had turned the Caped Crusader sour. And then Miller found Sin City.

Here, at Dark Horse, Miller invented a demi-monde perfectly suited for the sort of sordid tales he wanted to tell. Beginning with the brute force named Marvin, all the so-called good guys are bad guys, redeemed but briefly by a momentary, scarcely understood impulse that might pass for goodness, save for its motive: vengeance. These are uncompromising barbarians, ruthless outlaws, whose inarticulate sufferings and single-minded motivations and deeply, deeply frustrated yearnings for human affection in any form are all that make them humanly recognizable for most of us who read about them. Most of us, like all of them, are inarticulate and single-minded and somewhat frustrated in our longing to be loved in a world that seems inexplicably impersonal and uncaring. We are not, it seems, so very different.

Fascinated as Miller seems to be by this milieu (ours as well as his, after all), he is even more enthralled by the visual means he has adopted to reveal Sin City and its denizens. From the start of his professional career, he has struggled against the fetters of "house style" rendering. As *Daredevil* became, issue by issue, a better selling book, it would appear that Miller gained greater and greater freedom to follow his muse in both storyline and visual style. The license he was granted is most evident, in this title, in page design and pacing. But when he produced a six-issue series for DC in 1983-'84 called *Ronin*, Miller cast aside all preconceptions about artistic style, breaking rules on nearly every page. His breakdowns and page layouts were startling departures — page-wide horizontal panels, page-deep vertical panels, double-page spread panels;

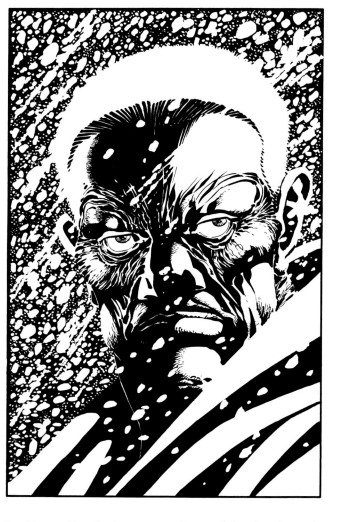

pages with one panel, pages with dozens of panels. Inking his own pencils, he used a simple, delicate line, sometimes texturing the pictures with hatching, sometimes leaving them in spare outline. Visual styling changed subtly from scene to scene to suit the mood of the sequence being rendered. The experience of producing *Ronin*, Miller later said, was the most liberating of his professional life. And then came *Sin City*. Here, again, Miller adopts a drawing style appropriate to the world he pictures.

And this may be as good a place as any, standing here on the threshold of a book of *Sin City* imagery, to remember how we started out — by saying that the medium of comics is a visual medium. Moreover — and more to my present point — comics is the natural habitat of cartoonists, those who, as I vouchsafed earlier, create in terms both visual and verbal, simultaneously invoked, seamlessly yoked. Regardless of the habitual visual-verbal blending in the act of conjuring up stories to tell, cartoonists are essentially visual, not verbal, artists. They draw. And they love to draw. No one becomes a cartoonist who does not love drawing. That's first. The stories are excuses that permit the cartoonist to draw. And this is a book of drawings, a celebration of drawing by a cartoonist who loves to draw.

Some of the drawings, ripped untimely from their narrative context, retain hints of their storytelling function. Others do not. All, however, speak wordlessly of the world Miller devised the style to depict. Black dominates the imagery. The black of drenching shadow, of a darkness so dense it can be pierced by only the tiniest slivers of light, a darkness that so completely cloaks the evil deeds being done in it that they could, except for Miller, have gone forever unobserved, unreported. Unpunished. Here, style creates the world in which Miller's misfits and malcontents shuffle and lurk and grind their teeth in suppressed rage, and women brazenly flaunt their bodies.

In devising this dark and brooding style for *Sin City*, Miller is clearly having some fun, playing a cartoonist's game. The game has only one rule: in picture after picture, Miller seems to be challenging himself to see how much he can leave out of the visual and still maintain a narrative function. As examples of graphic artistry, his stories are cunningly orchestrated omission. Miller is simplifying. Or maybe the word is *purifying*. He's purifying narrative pictures, distilling from them only the essential storytelling imagery. It's as if he's trying to see how much narrative meaning can be hinted at rather than delineated. This is a maneuver peculiar, I dare say, to comics. It cannot be performed in other media as effectively.

The cartoonist is somewhat like the filmmaker. Both think, create, in visual terms (in tandem with sound and/ or verbal content, admittedly, but fundamentally visual), but the filmmaker's visuals are in continuous motion; the cartoonist's visuals are static, punctuation marks that identify key moments in an ongoing action or unfolding story. Because the cartoonist's pictures are motionless, they remain before the viewer's gaze indefinitely. They can be studied, examined for meaning and implication. The viewer can expand upon the visual hints in the pictures, filling in the blanks, so to speak, with a scene only hinted at in such pictures as Miller has produced for much of the *Sin City* series.

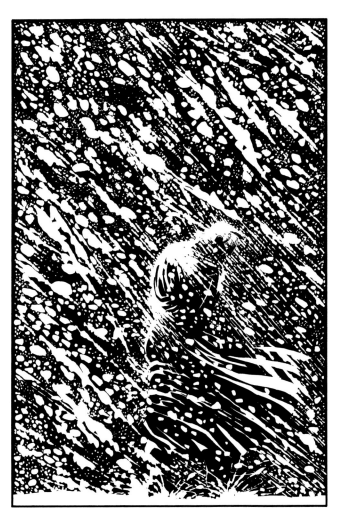

This volume supplies the most vivid demonstration yet of the art of leaving things out. Among the pages of finished drawings herein are a few of the preliminary sketches, and by comparing the sketch to the final work, we can see the extremity to which Miller has taken the stratagem. The girl disrobing from *Hell and Back* #6 (page 47), for instance. Almost nothing of the preliminary linework is left; form and shape are indicated by highlighting and contrasting. And, again, in the tip-in art for the limited edition hardcover of *Family Values* (page 87), a riveting Oriental refinement has emerged from the preliminary drawing. Stunning as these images are, the practice is equally effective in a more narrative mode, as,

for example, the scene from *A Dame to Kill For* #4 (page 31) in which the girls from Old Town pour lead into the cop car. Deployment of solid black permits Miller to leave out all but the most telling details: no background, no curbstone or street trash, the scene is set by the tile on the rooftop and the angle of the composition, and the action is depicted with the simplest glyphs for the actors.

Miller's technique, while seemingly simple, became quite complex in successive *Sin City* books. At first, he worked mostly in bold, solid shapes of which the framing doorway scene from *Silent Night* (page 20) and Marvin contemplating the dawn (page 27) or in the brothel asking for handcuffs (page 55) or the protagonist in the alley from *The Big Fat Kill* (page 26) are fair examples. The operative principle seems to be to shroud everything in deep shadow. The prevailing image is solid black, and figures and shapes are defined by highlights that are created by a single light source in an otherwise completely darkened setting. Marvin breaking into a run (page 11) and, later, in the electric chair (page 28) are typical. And again, in a startling example from *A Dame To Kill For* #5 (page 42), the lovers' bodies are shaped almost entirely by the shadows thrown from the light coming through the window.

In the first variation on the shadowy ploy, Miller merely reverses the palette: suddenly, the dominant image is starkly, screamingly white, and figures and shapes are delineated by flecks of black shadow. The most dramatic example at hand of this approach is the scene in the snow outside the mansion from "Daddy's Little Girl" (page 72), particularly the bottom half-page panel in which every semblance of line has been sleeted out, leaving only icy hints of form as supplied by blocks of solid black. This page is from Miller's later period, but the impulse to define by shadow as well as by highlights is apparent in the earliest work: say, the picture of Marvin climbing the brick wall from *Dark Horse Presents* #52 (page 12).

The next development in the evolution of this style saw Miller discard the mechanical device of a light source and work purely in contrasting black-and-white. The naked, gun-brandishing babe from the *Sin City Collector Cards* (page 35) is, so to speak, a revealing instance. The light source, at first blush, seems to be at the upper left, splashing light on the right side of the woman's face and breasts and torso. But if the light comes from the upper left, how can her left shoulder and arm be highlighted? They would be in the shadow of her head, at least. And the back of her left thigh would scarcely be lighted from that angle. No, by this time, Miller is defining shapes through the sheer contrast of black-and-white; the light source device, so brilliantly employed, say, with the lovers in *A Dame to Kill For* (page 42), is no longer a controlling tactic. Contrast alone shapes the images — dazzlingly! — of Nancy dancing in her cowgirl outfit in *That Yellow Bastard* (page 95) and of the naked Ava in *A Dame to Kill For* (page 85). And in such circumstances as the operating room sequence in *That Yellow Bastard #2* (page 52), we see the gambit taken to its logical extreme: here, black becomes, in effect, a "color," arrayed against solid white and augmented by fragile linework.

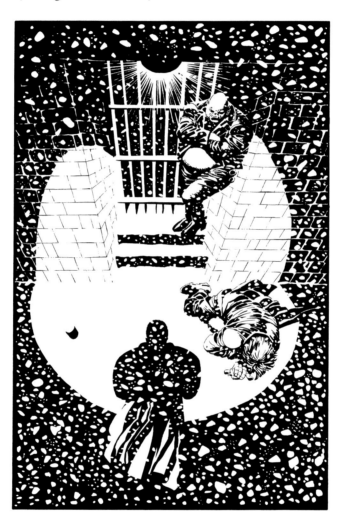

Line has figured in every stage in the evolution of this style. At first, Miller seems determined to avoid line altogether, but he soon begins to use it as a decorative motif to create the visual relief of texture amid the solid blacks and whites. It is first most evident in the rendering of Marvin's furrowed visage, but linear treatment appears elsewhere, too — as a column of smoke, say, from a smoldering cigarette or as the nap of a knitted sweater or as ringlets in a woman's hair. In the promotional drawing of the protagonist and three babes (page 57) for *The Big Fat Kill*, for instance, we have a cascade of differing textures against the usual contrasting solid blacks and whites.

The contrastive character of his treatment quickly led Miller to devise patterns, too, as well as textures for visual variety: the tile roof in *Sin City*'s episode 13 (page 63), for example, or the linear pattern created by light through the blinds in *A Dame To Kill For #2* (page 37). And patterns become chaotic in rendering the layered atmosphere in the smoke-filled dens of Old Town iniquity or in the pelting rainstorm that concludes *The Big Fat Kill*. The impulse for texture eventually leads Miller to splattering a fine spray of white ink across solid black to soften the visual impact of the otherwise unrelieved darkness, as in the treatment of the pinup on the back cover of *Hell and Back #6* (page 77).

And then came color. At first, it was the occasional splash of crimson that accented the black-and-white in "The Babe Wore Red" and then a corrosive yellow in *That Yellow Bastard* and, finally, the tonal variations created by Lynn Varley that subtly modulate or enhance the impact of the black-and-white drawings.

While some of Miller's technique evolved through a succession of *Sin City* books, the progression was undoubtedly not as incremental or logical (or, even, as deliberate and conscious) as I've made it seem in this discussion. Delineation by contrast alone was always implicit in the chiaroscuro of his initial foray into light and shadow. And the visual variety that could be achieved with a filigree of fine linework was inherent in the first books; over the ensuing decade, Miller simply elaborated upon his initial impulse, consciously recognizing, no doubt, by the end of the period, what he instinctively knew at the beginning. The evolution of an artist's sensibility and methods is never an entirely orderly matter. And it never ends. But some of the more recent stages in Miller's growth and development as an artist are displayed within, punctuation marks in a steadily evolving talent. You should now turn the page and savor the visual delights at the right, contemplate this stylistic tour de force that conjures up the world in which the cartoonist tells his tales and that becomes, thereby, part of the narrative itself — as it ever must in a visual medium in which drawings are the very essence.

"HEROES DON'T GO WEAK IN THE KNEES AND FEEL LIKE THROWING UP OR CURLING UP INTO A LITTLE BALL AND CRYING LIKE A BABY."

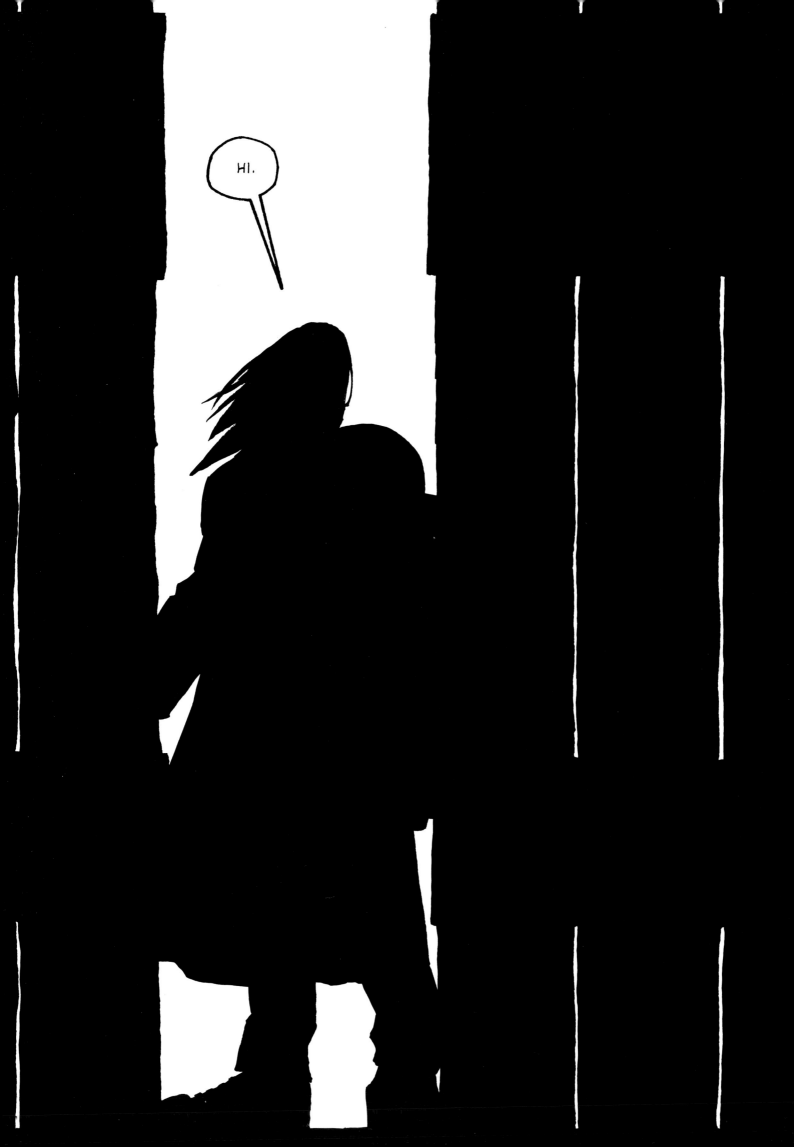

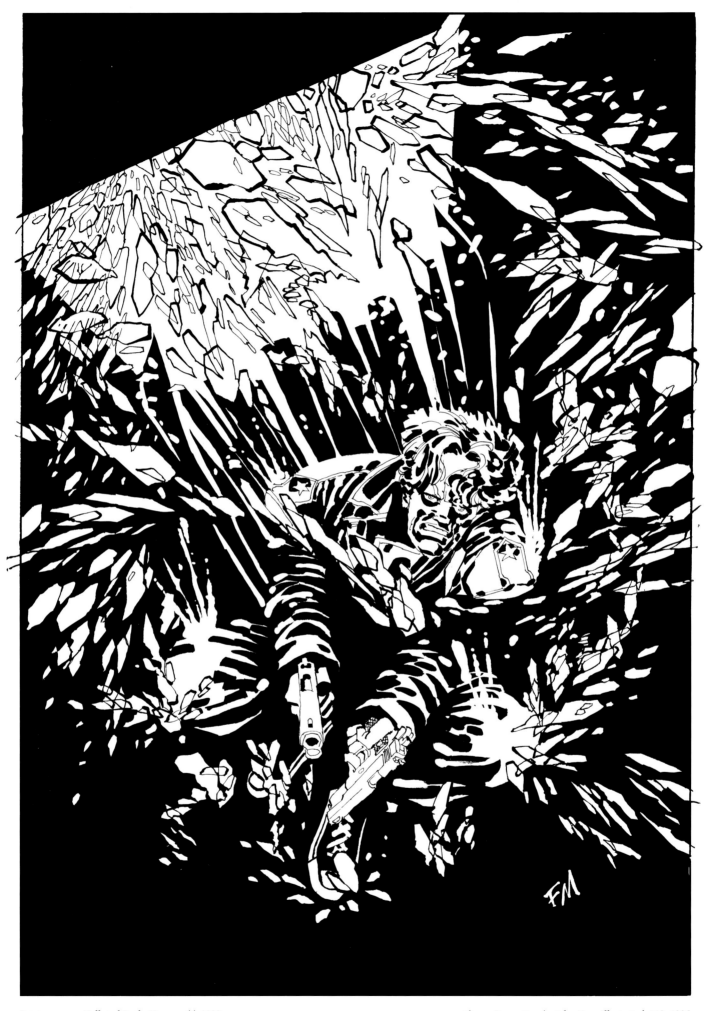

Previous page: *Hell and Back* #9, page 44, 2000

Above: Promotional art for *Hero Illustrated* #18, 1995

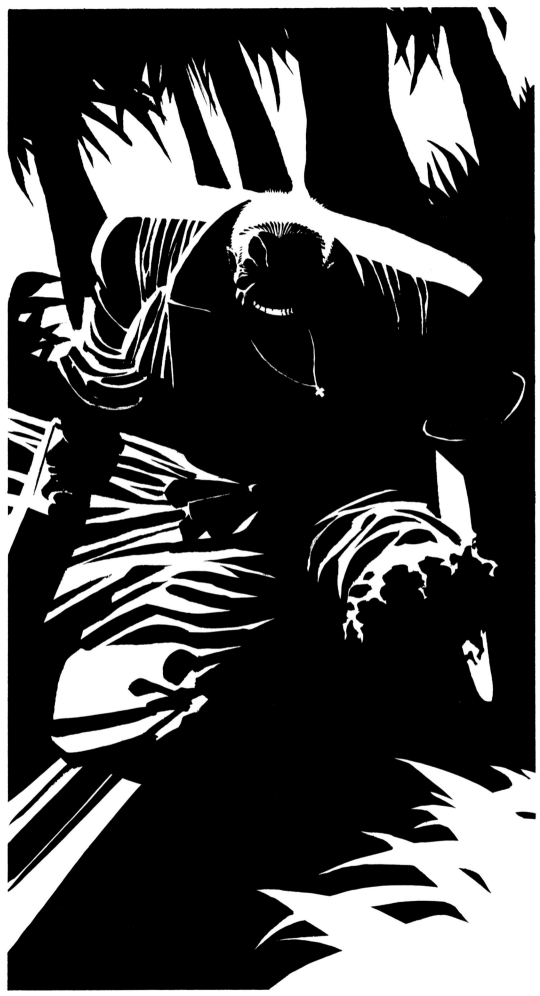

IT ISN'T LONG
BEFORE I BREAK
INTO A RUN. I CAN'T
HELP MYSELF.

NO SHAKING, NOW.
NO COLD SWEAT. NO
DOUBTS. THE FEAR
GOT OUT FOR A
LITTLE WHILE THERE
BUT NOW IT'S
CRAWLED BACK IN,
FAR AWAY, A SMALL
COLD THING LOST
IN A BELLY THAT'S
FULL OF FIRE.

EVEN THE WOODS
DON'T SCARE ME
ANYMORE BECAUSE
I'M JUST ONE MORE
PREDATOR AND I'M
BIGGER AND
MEANER THAN
THE REST.

ALL I'VE EVER
BEEN GOOD AT IS
KILLING SO I
MIGHT AS WELL
ENJOY IT.

Sin City trade paperback, page 164, 1993

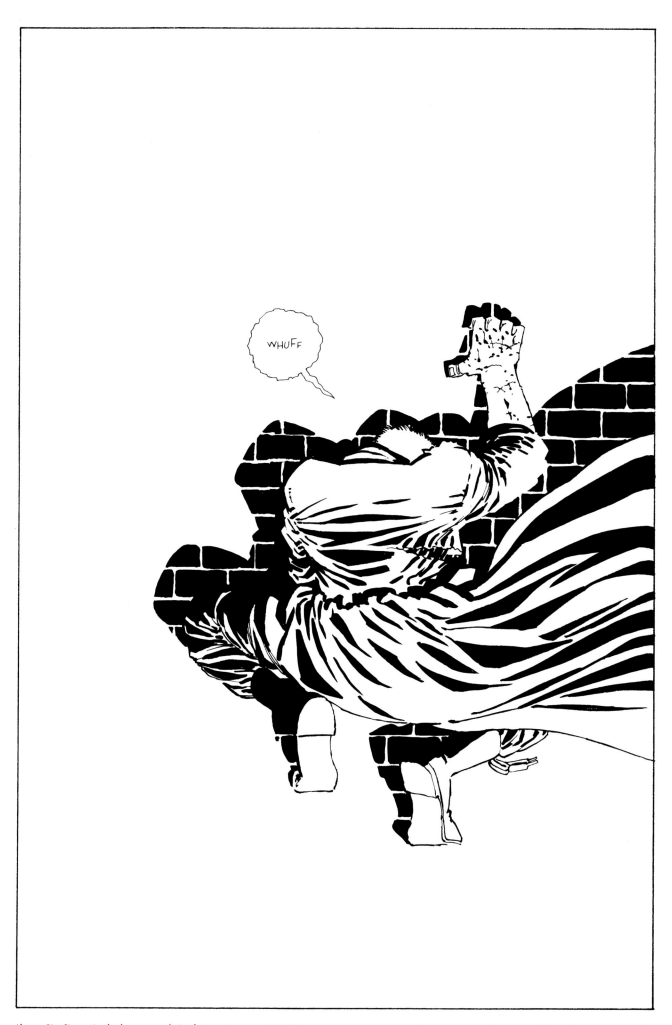

Above: *Sin City*, episode three, page 6, *Dark Horse Presents* #52, 1991

Opposite page: *A Dame To Kill For* #1, front cover, 1993

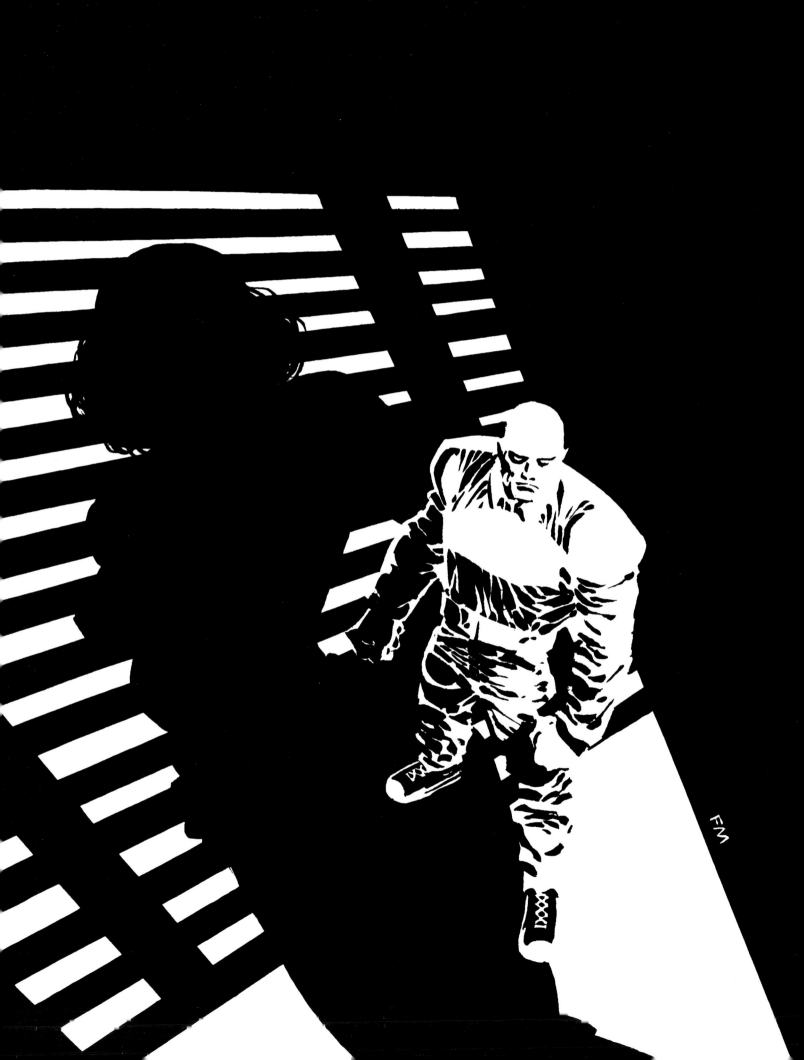

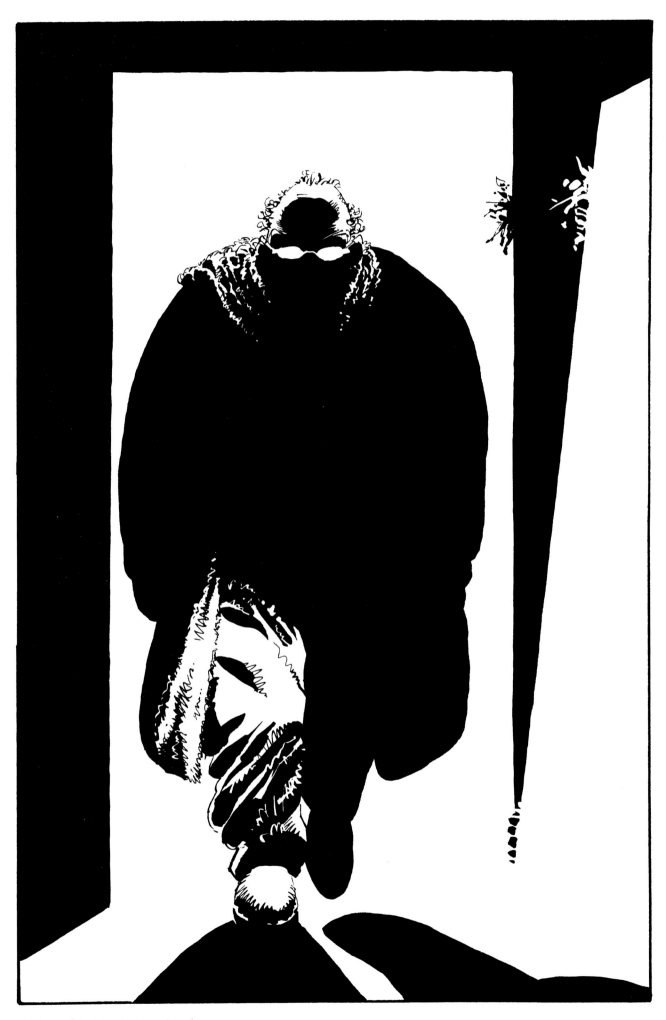

"Rats," page 6, *Lost, Lonely, & Lethal*, 1996

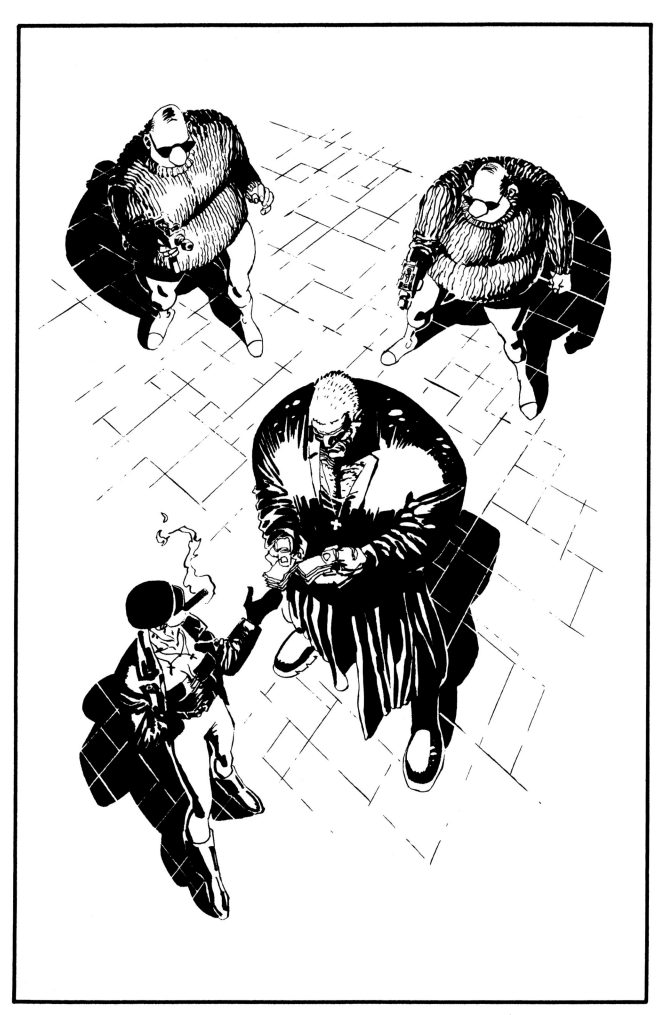

Silent Night, page 11, 1995

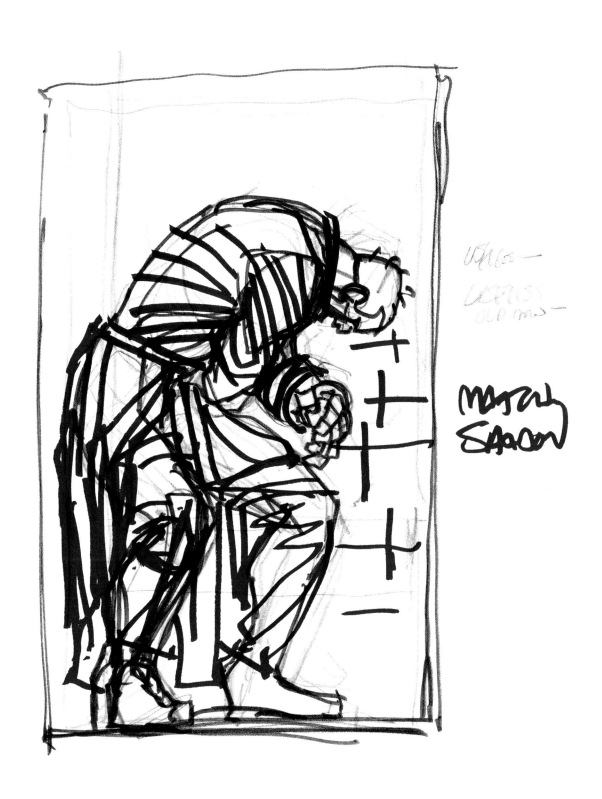

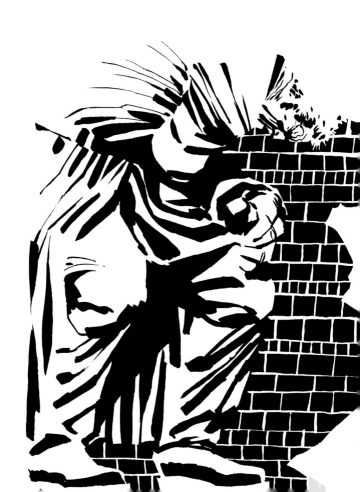

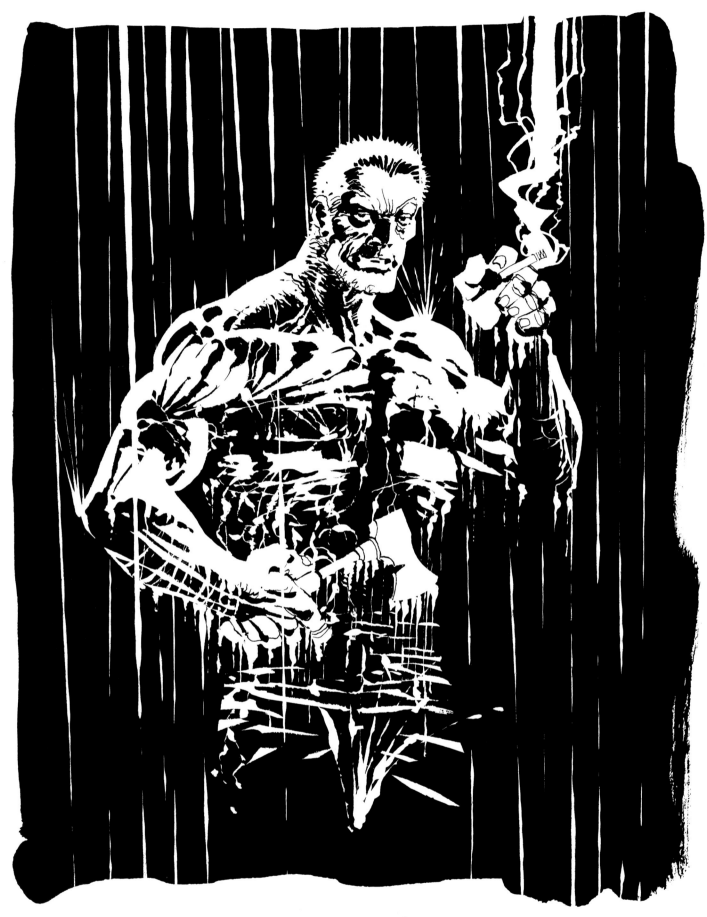

THERE'S NOTHING LIKE A
GOOD SMOKE AFTER A
HARD DAY'S WORK.

Sin City Collector Cards #15, 1999

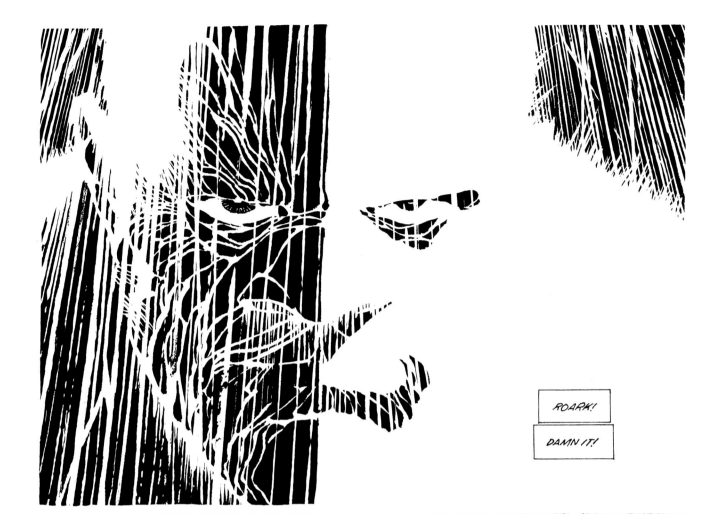

ROARK!

DAMN IT!

EVERY INCH OF ME WANTS TO TURN TAIL, TO SNEAK INTO THE BACK OF A TRUCK OR HOP A FREIGHT CAR AND HAUL OUT OF TOWN. I WANT TO RUN, RUN LIKE HELL, TO CRAWL INTO A CAVE SOMEWHERE AND FORGET ABOUT GOLDIE AND LUCILLE AND SILENT, DEADLY KEVIN.

ROARK. DAMN IT.

I'M AS GOOD AS DEAD.

I'M AS GOOD AS DEAD.

AND IT'S NOT THAT I'M ANY KIND OF HERO THAT MAKES ME STAY. HEROES DON'T GO WEAK IN THE KNEES AND FEEL LIKE THROWING UP OR CURLING UP INTO A LITTLE BALL AND CRYING LIKE A BABY.

Sin City, episode eleven, page 3, *Dark Horse Presents* #60, 1992

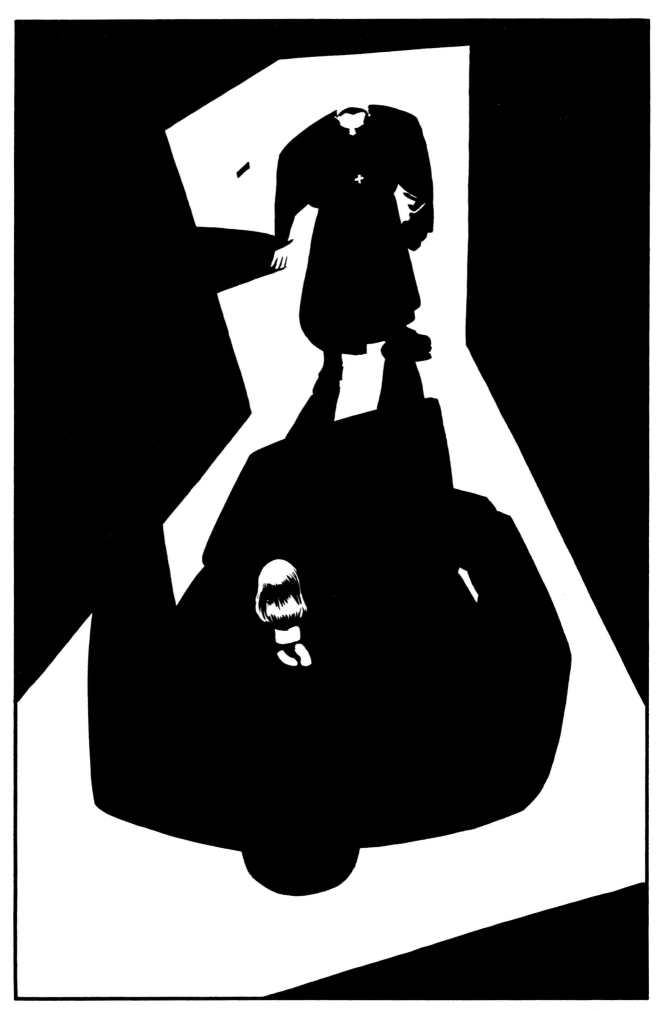

Silent Night, page 21, 1995

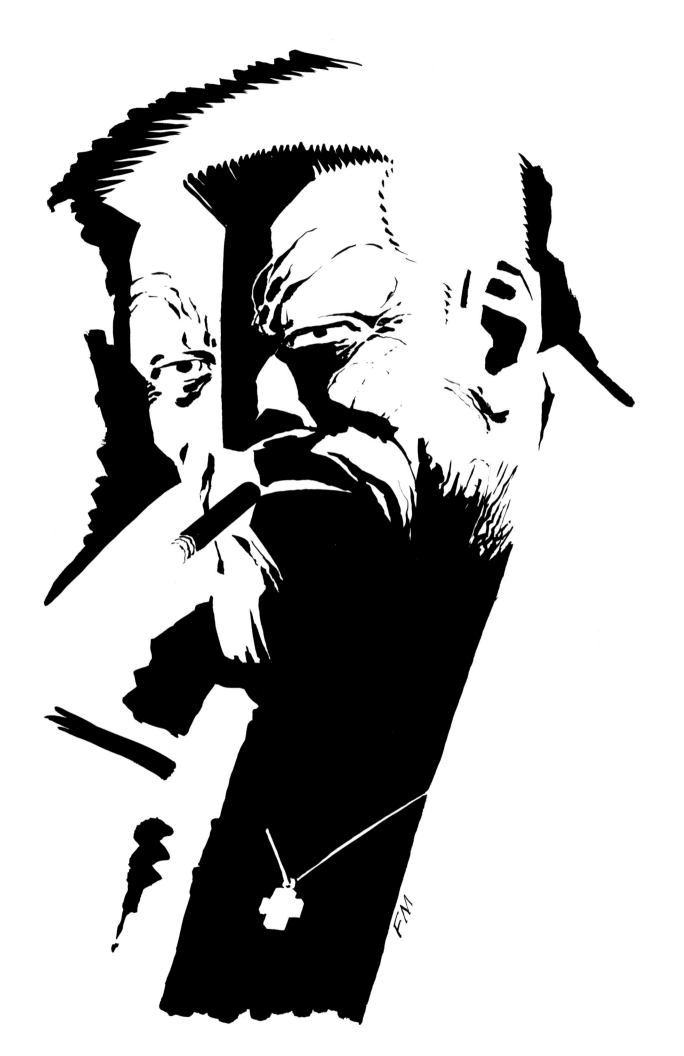

Sin City 10th Anniversary Edition limited edition print, 2001

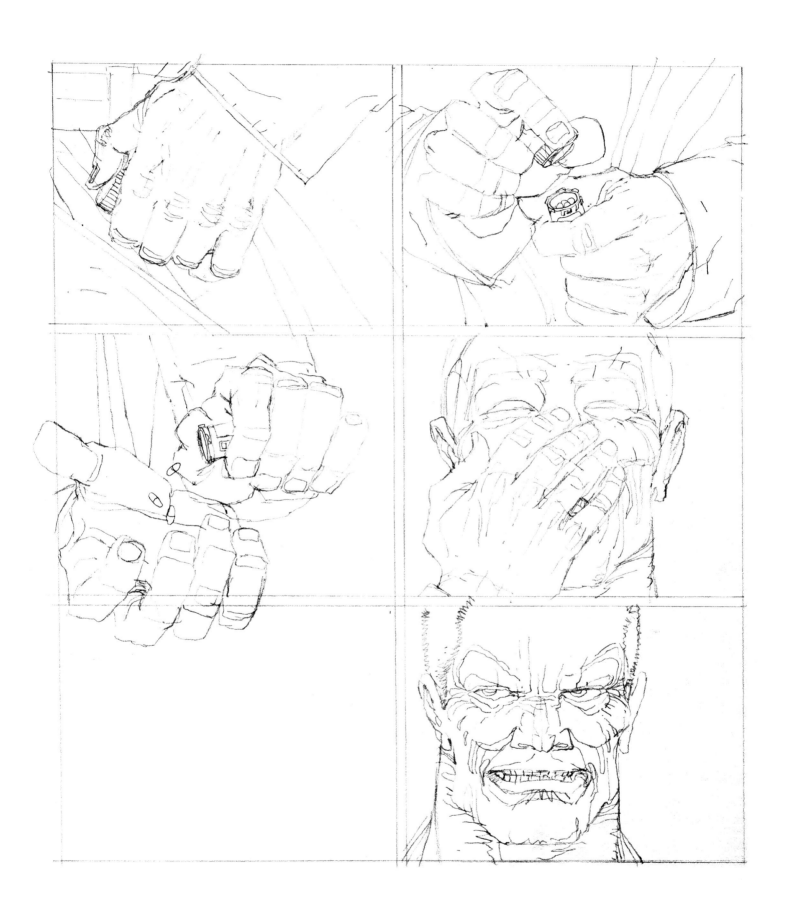

Preliminary pencils, *Sin City*, episode two, page 3, *Dark Horse Presents* #51, 1991

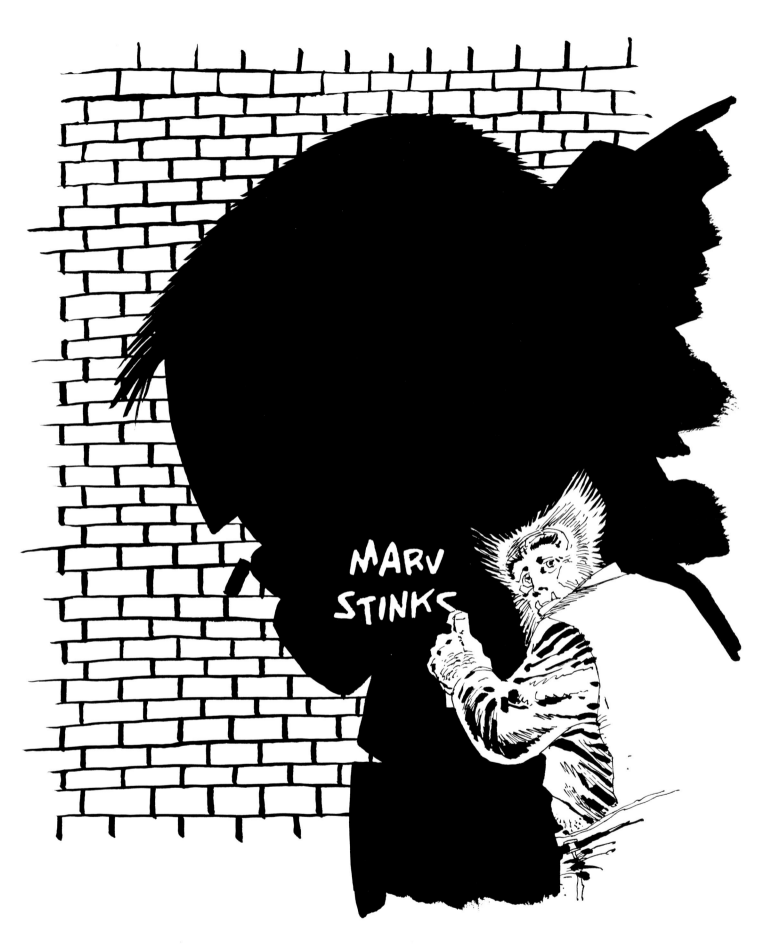

SOME GUYS JUST NEVER LEARN.

Sin City Collector Cards #13, 1999

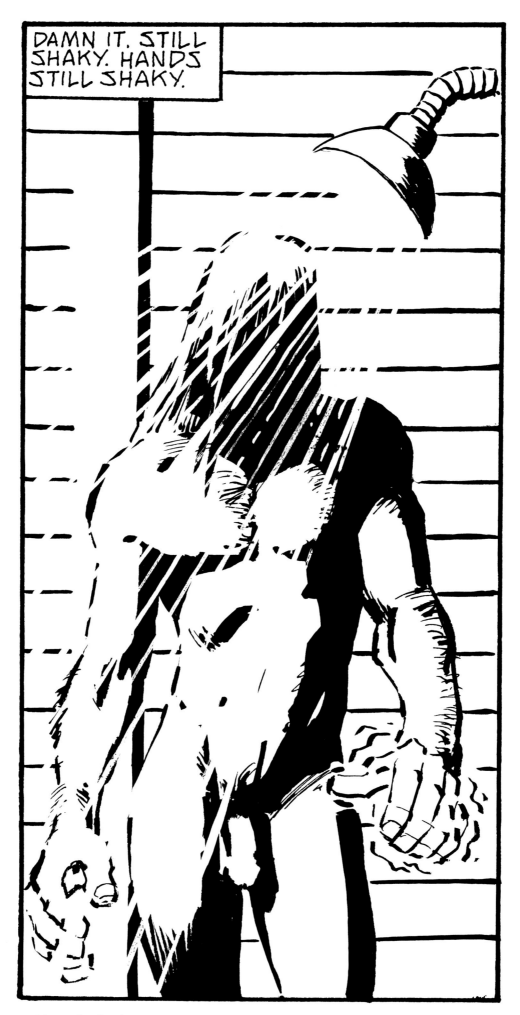

Detail from *Hell and Back* #8, page 24, 2000

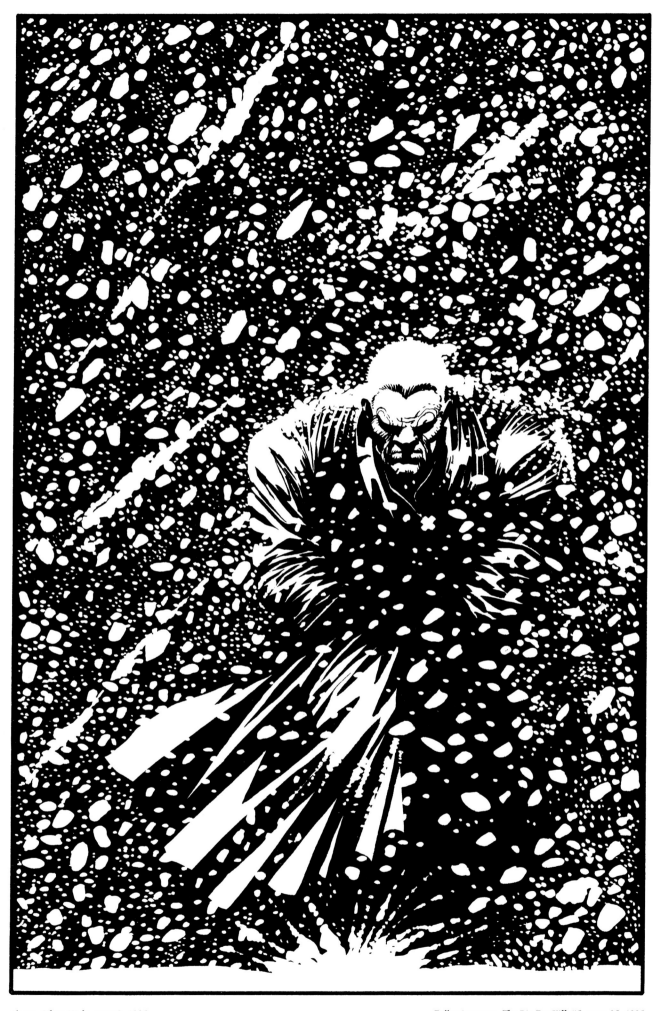

Above: *Silent Night*, page 3, 1995

Following page: *The Big Fat Kill* #5, page 25, 1995

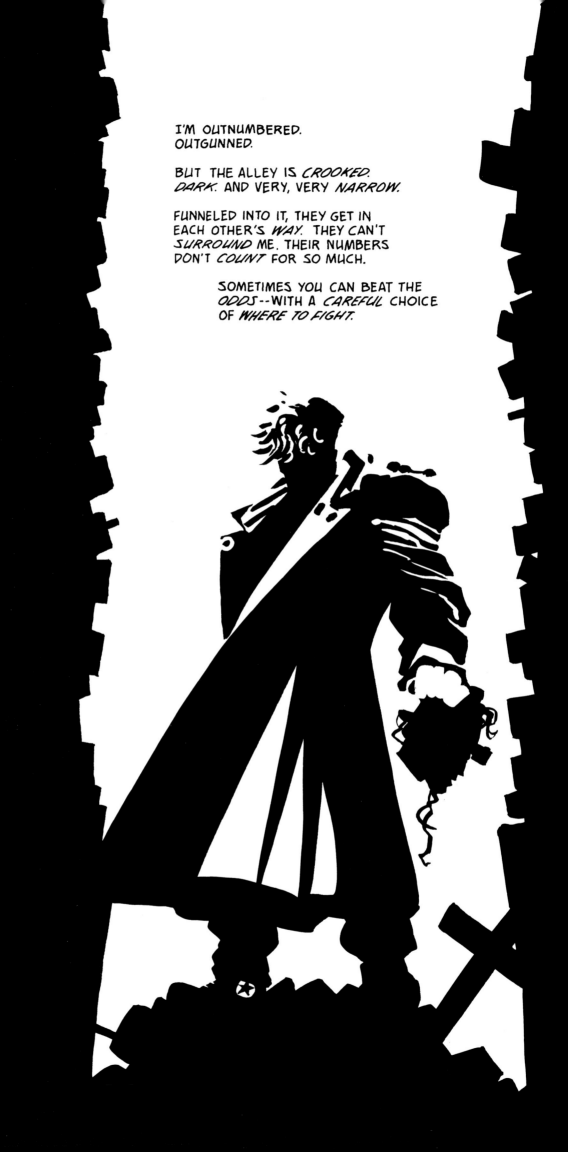

I'M OUTNUMBERED.
OUTGUNNED.

BUT THE ALLEY IS *CROOKED.*
DARK. AND VERY, VERY *NARROW.*

FUNNELED INTO IT, THEY GET IN
EACH OTHER'S *WAY.* THEY CAN'T
SURROUND ME. THEIR NUMBERS
DON'T *COUNT* FOR SO MUCH.

SOMETIMES YOU CAN BEAT THE
ODDS--WITH A *CAREFUL* CHOICE
OF *WHERE TO FIGHT.*

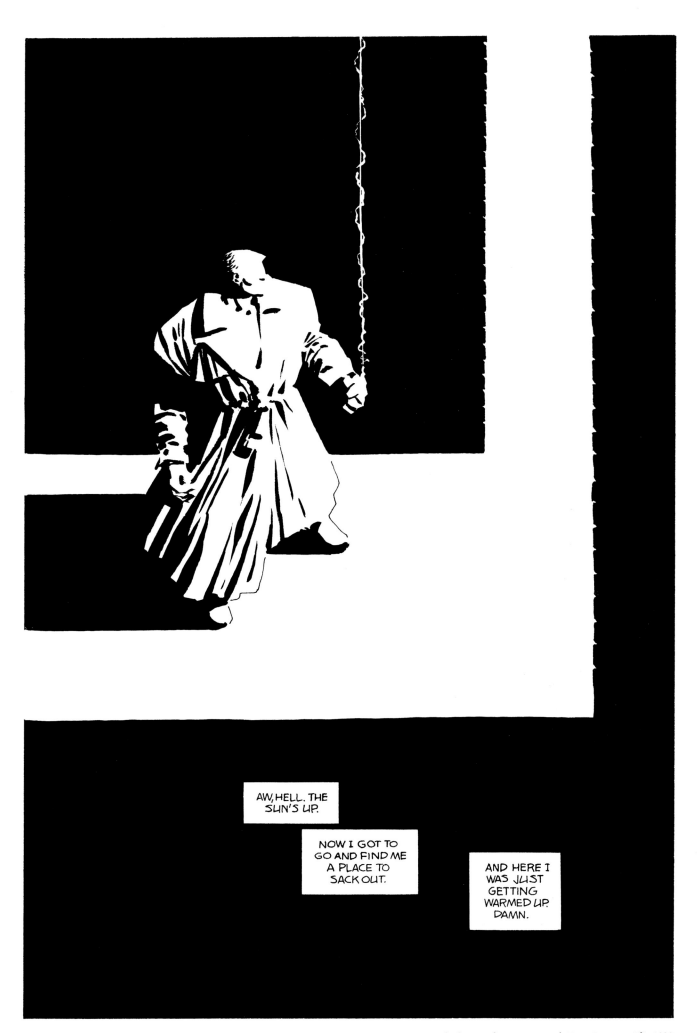

AW, HELL. THE SUN'S UP.

NOW I GOT TO GO AND FIND ME A PLACE TO SACK OUT.

AND HERE I WAS JUST GETTING WARMED UP. DAMN.

Above: *Sin City* trade paperback, page 66, 1993 Following page: *Sin City*, episode thirteen, front cover, *Dark Horse Presents* #62, 1992

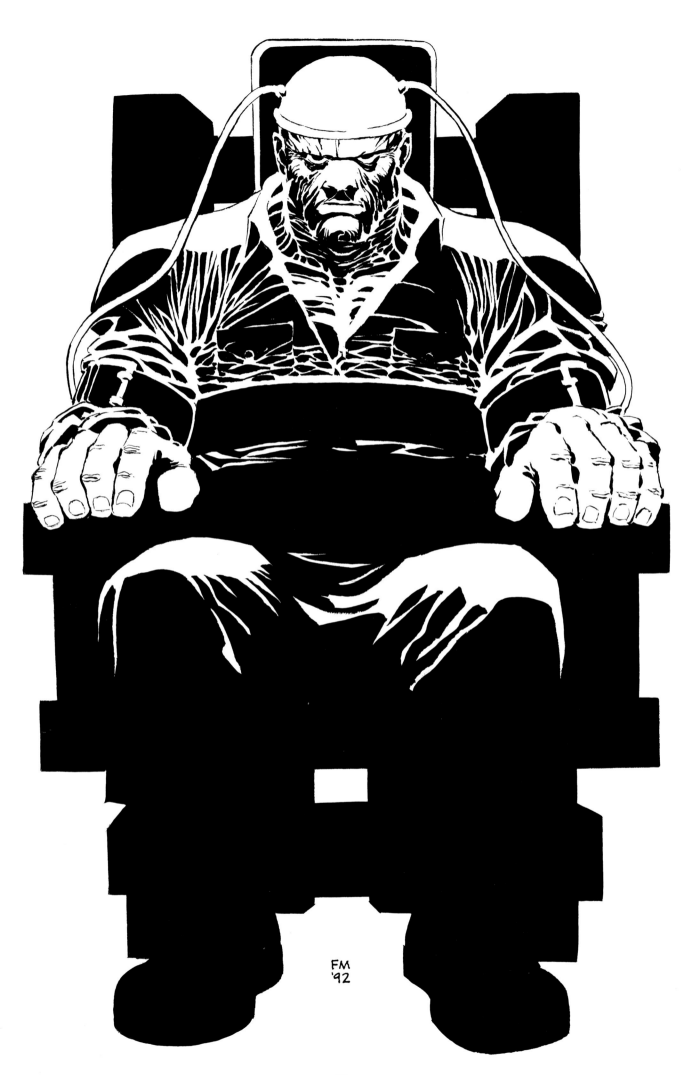

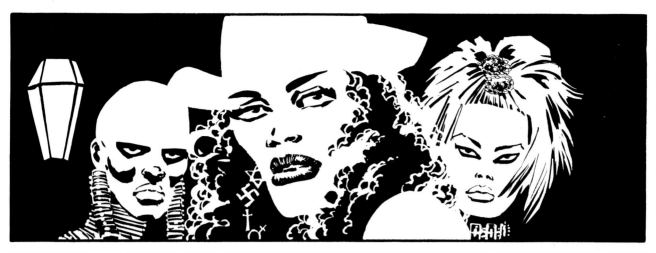

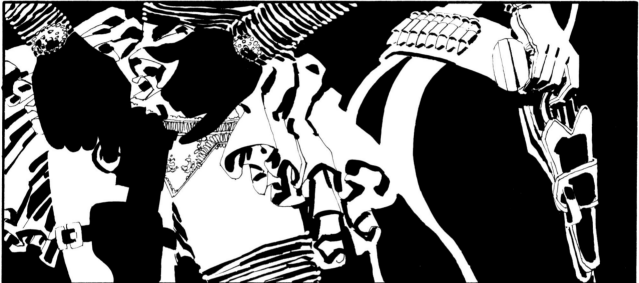

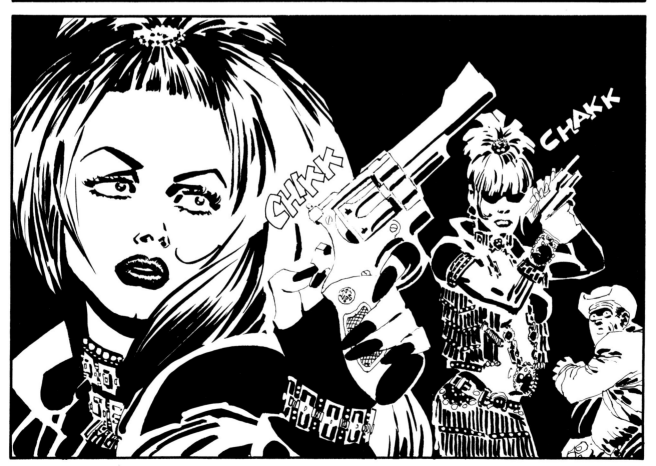

The Big Fat Kill #1, page 20, 1994

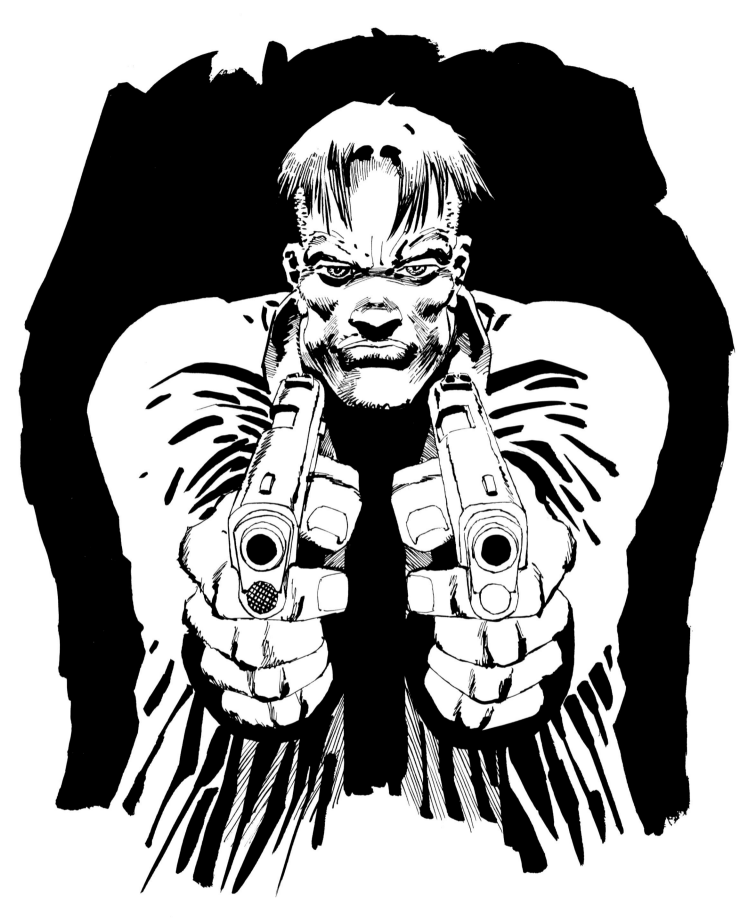

AND HE'S THE NICE GUY OF
THE BUNCH.

Sin City Collector Cards #68, 1999

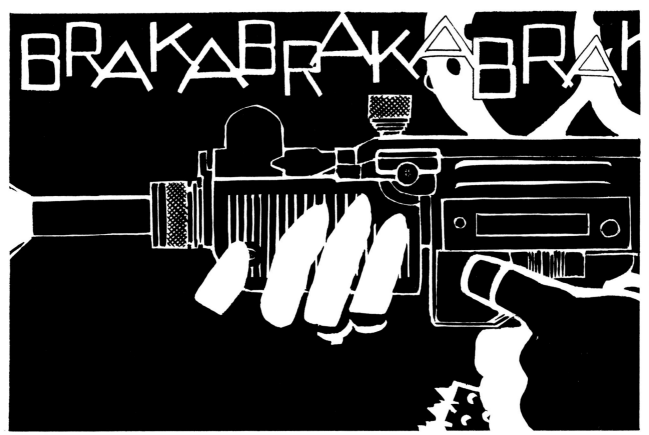

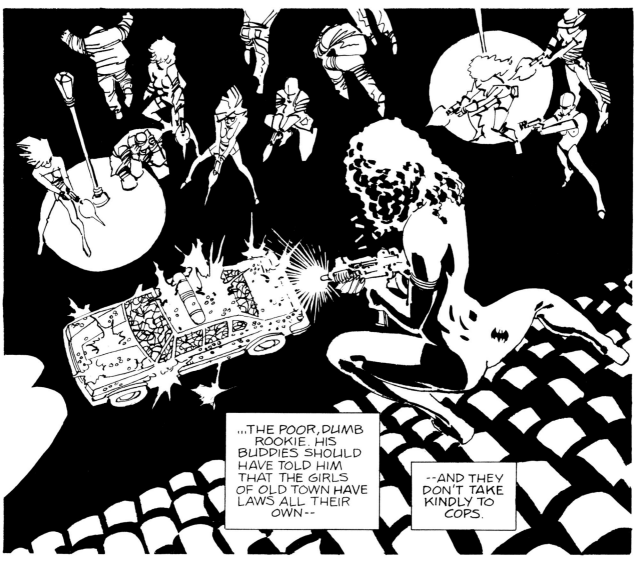

A Dame To Kill For #4, page 22, 1994

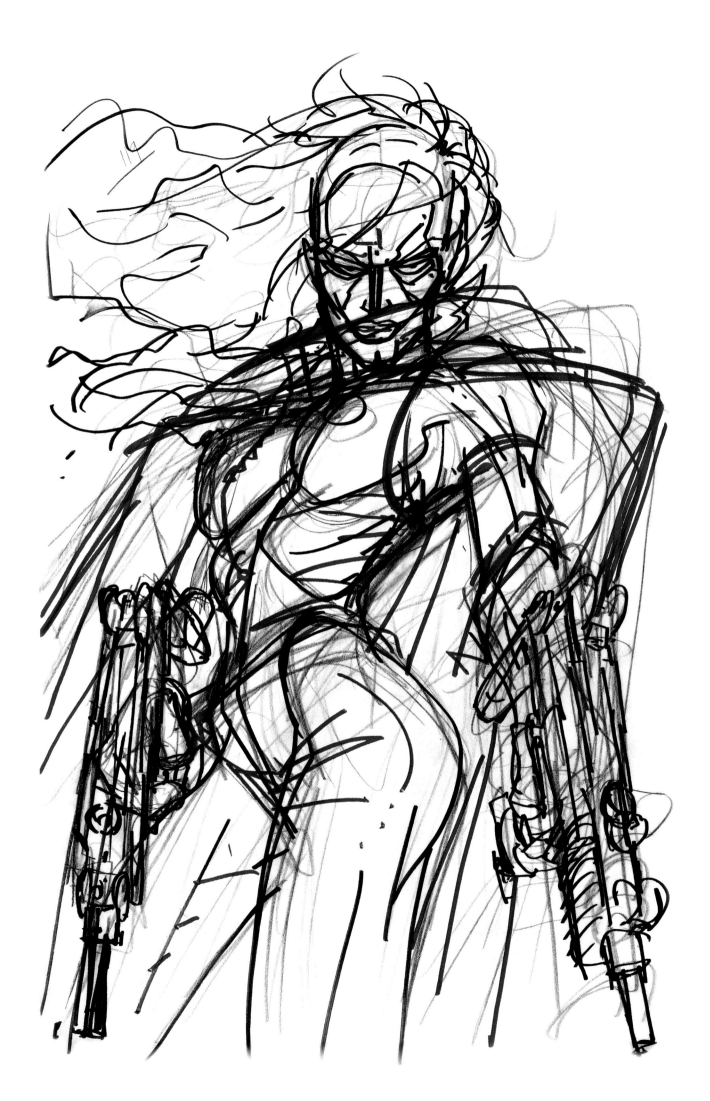

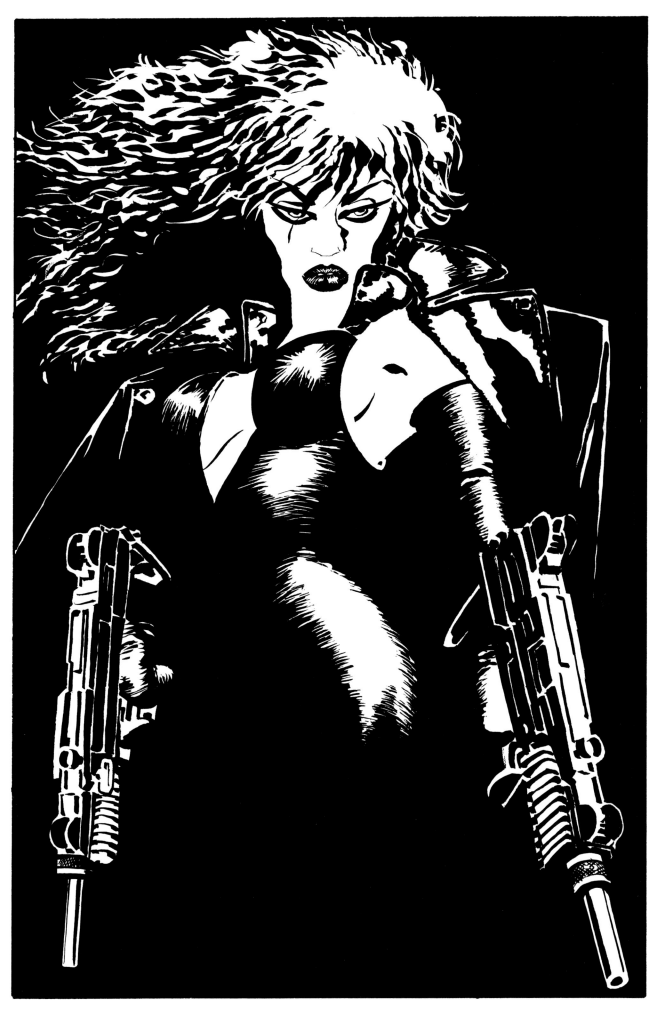

Above and opposite: *Family Values*, page 121, 1997

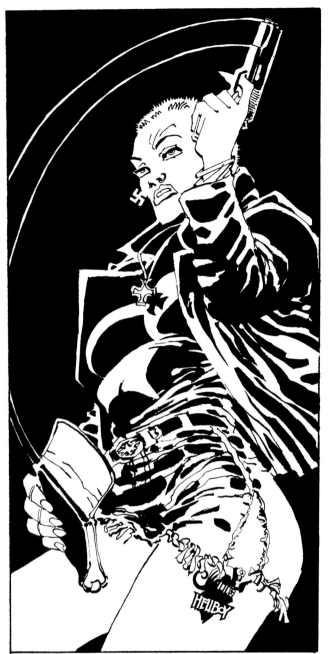
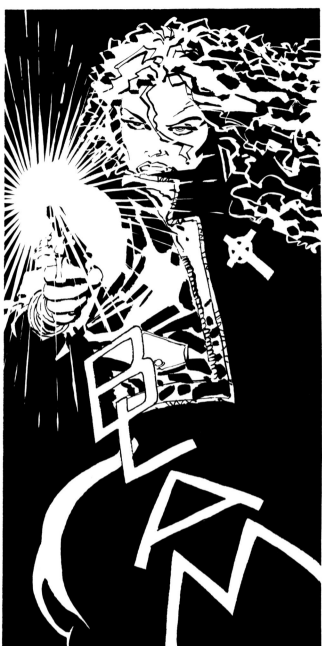
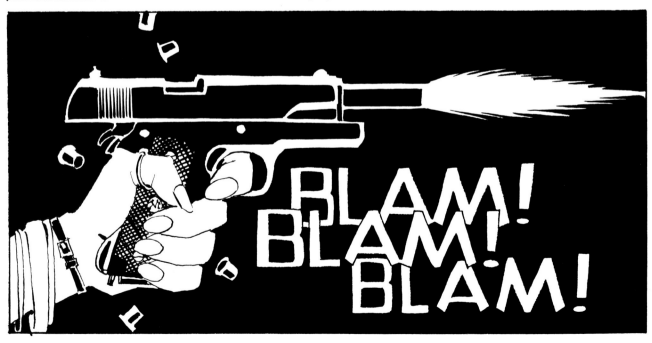

A Dame To Kill For #4, page 21, 1994

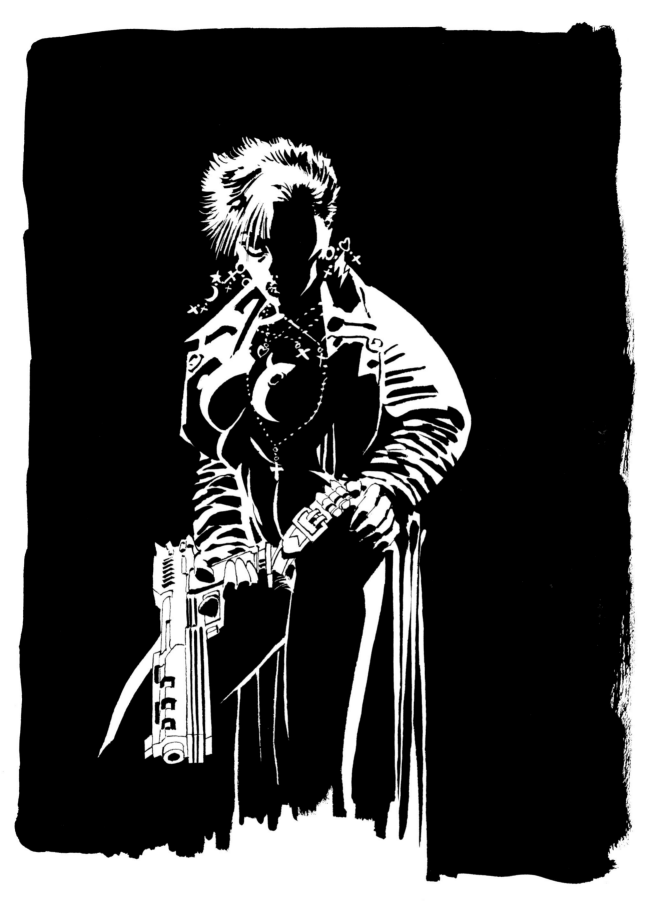

THE SLASHER WAS BRAGGING
ABOUT WHAT HE HAD BETWEEN
HIS LEGS. THEN HE SAW
WHAT SHE HAD BETWEEN HERS.

Above: *Sin City Collector Cards* #66, 1999

Following page: *That Yellow Bastard* #1, back cover, 1996

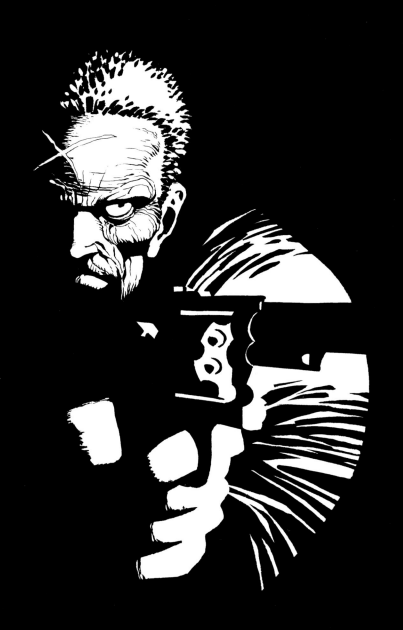

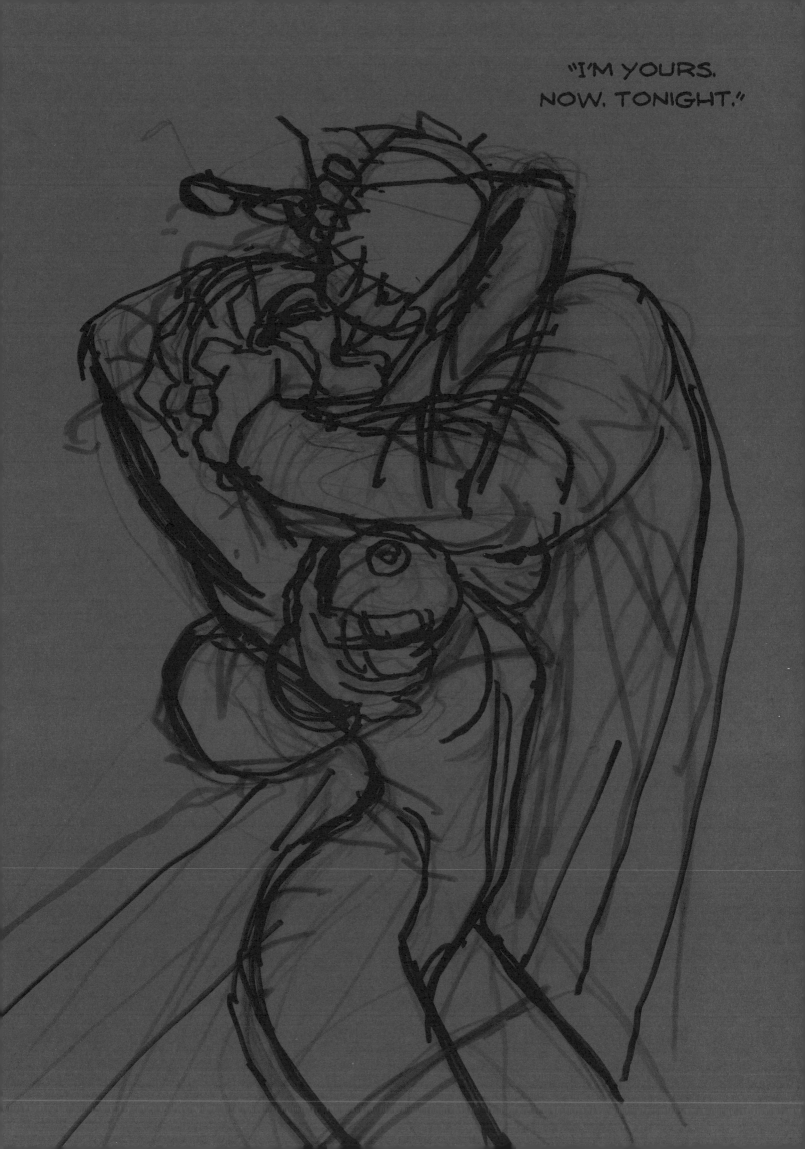

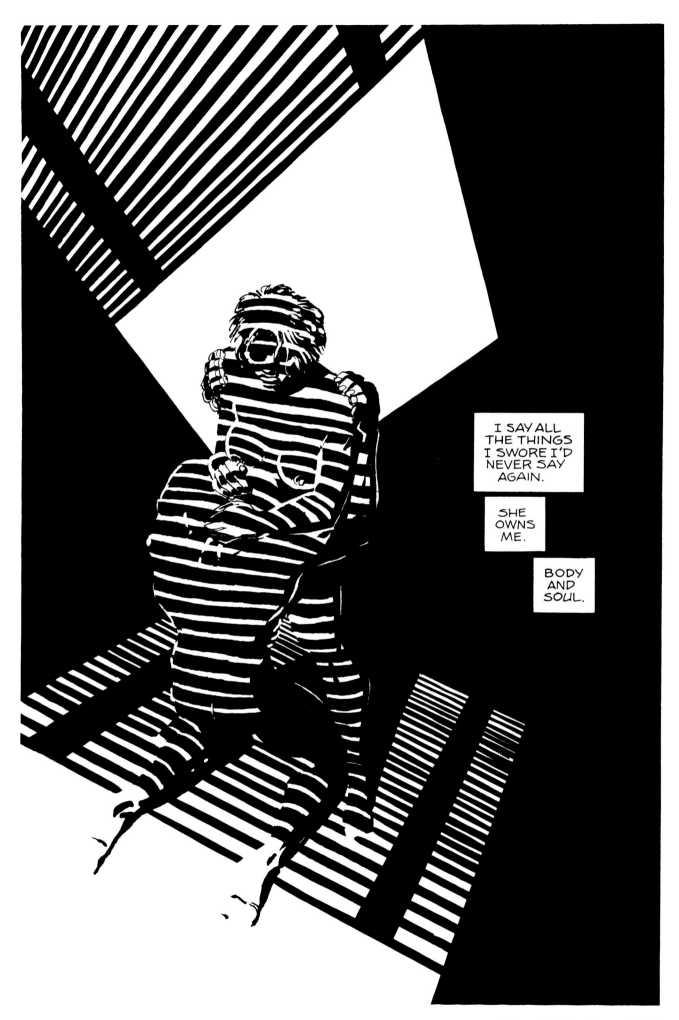

A Dame To Kill For #2, page 23, 1994

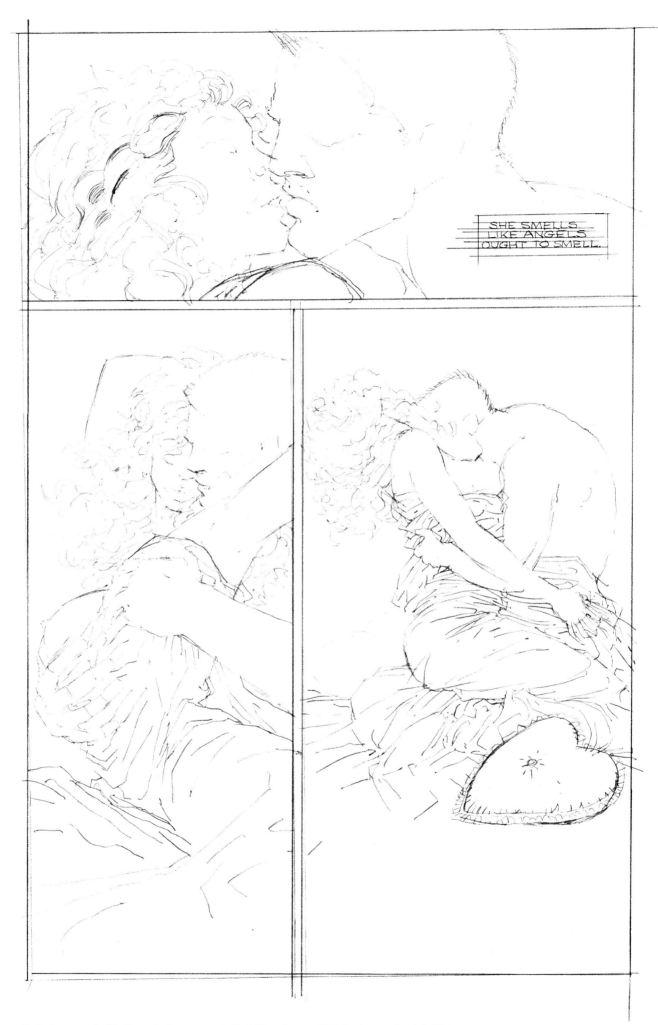

Preliminary pencils, *Sin City*, episode one, page 3, *Dark Horse Presents Fifth Anniversary Special*, 1991

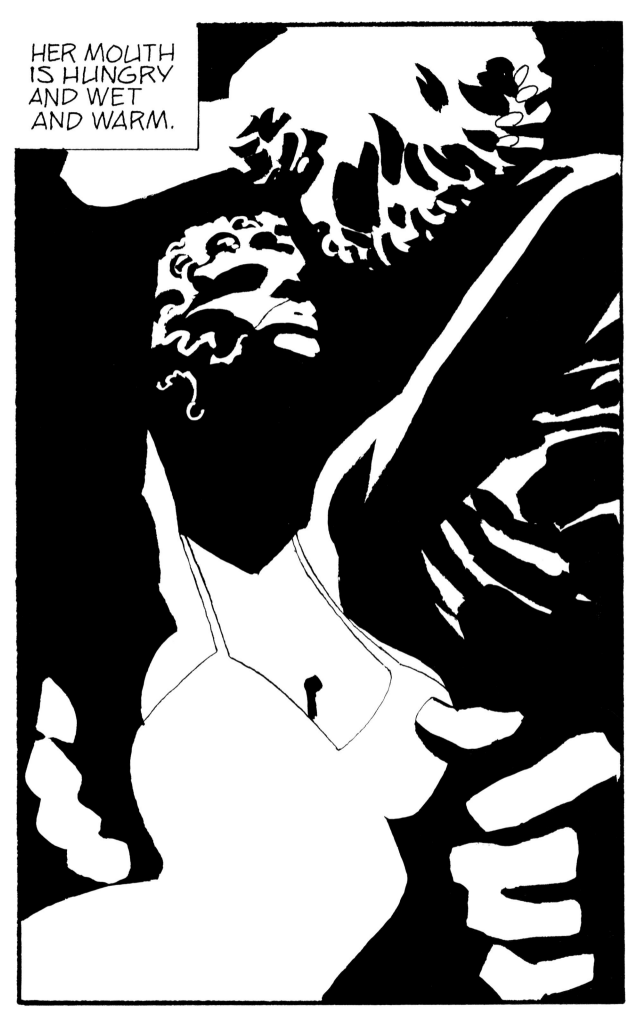

Detail from "The Babe Wore Red," page 18, *The Babe Wore Red and Other Stories*, 1994

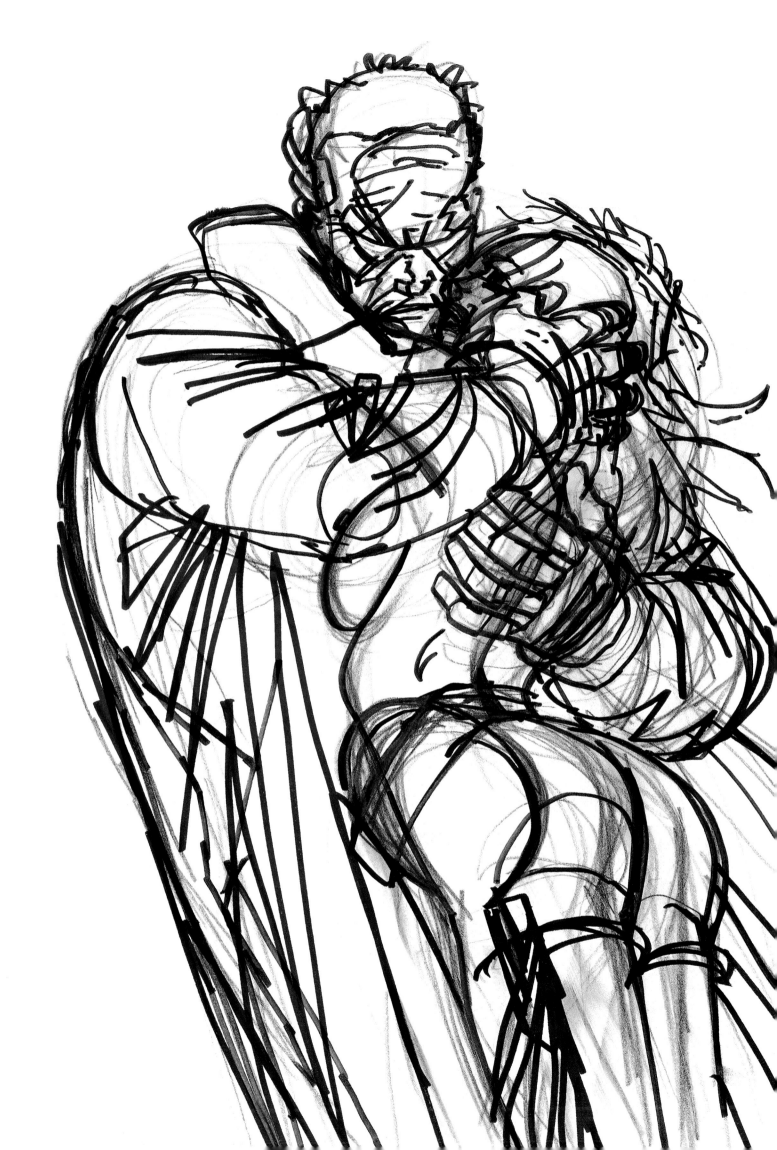

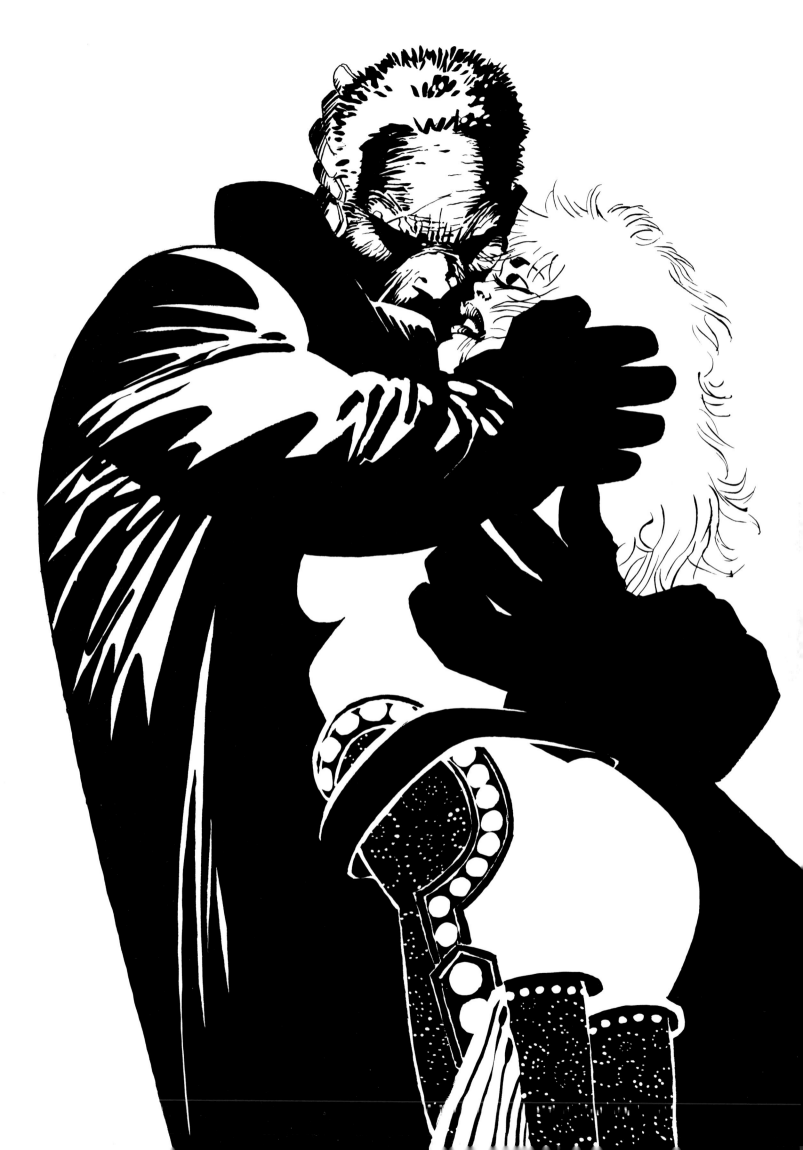

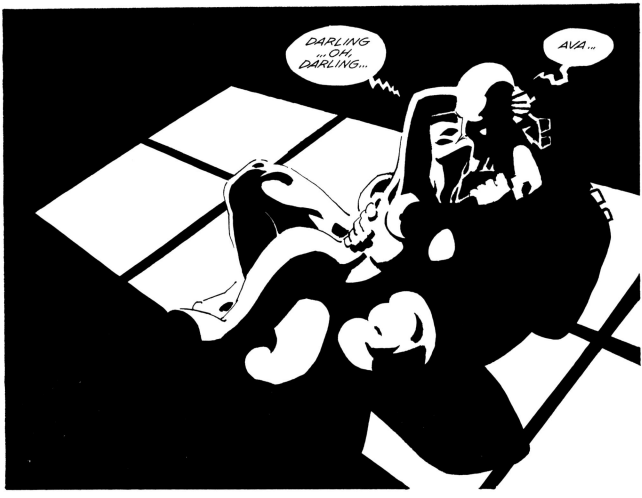

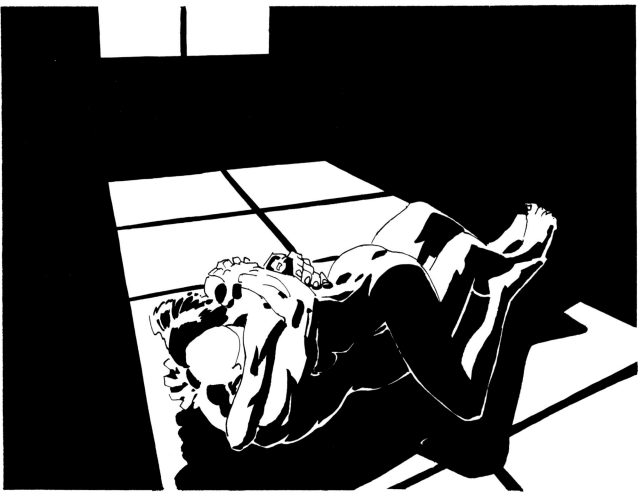

Previous pages: *That Yellow Bastard* #5, page 13, 1996

Above: *A Dame To Kill For* #5, page 16, 1994

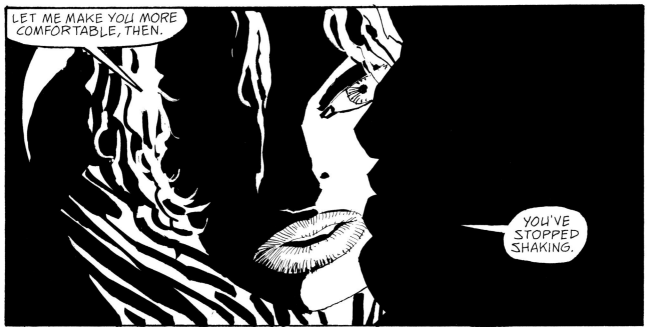

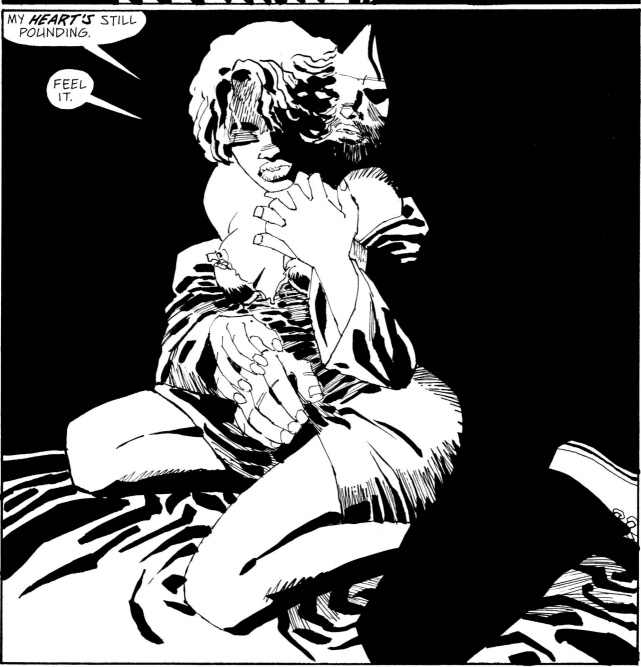

Hell and Back #4, page 16, 1999

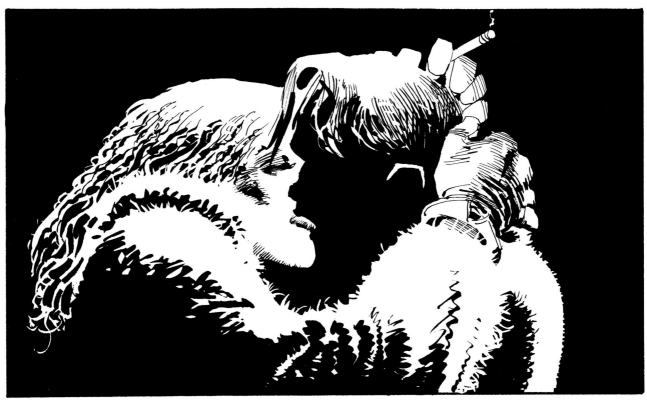

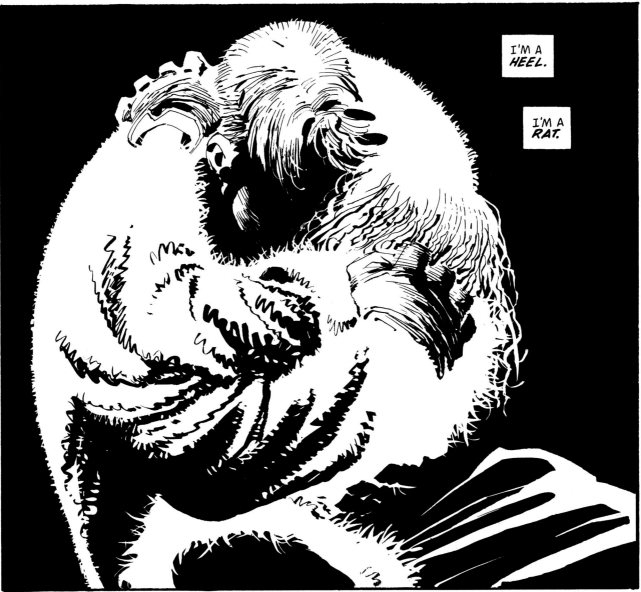

Family Values, page 21, 1997

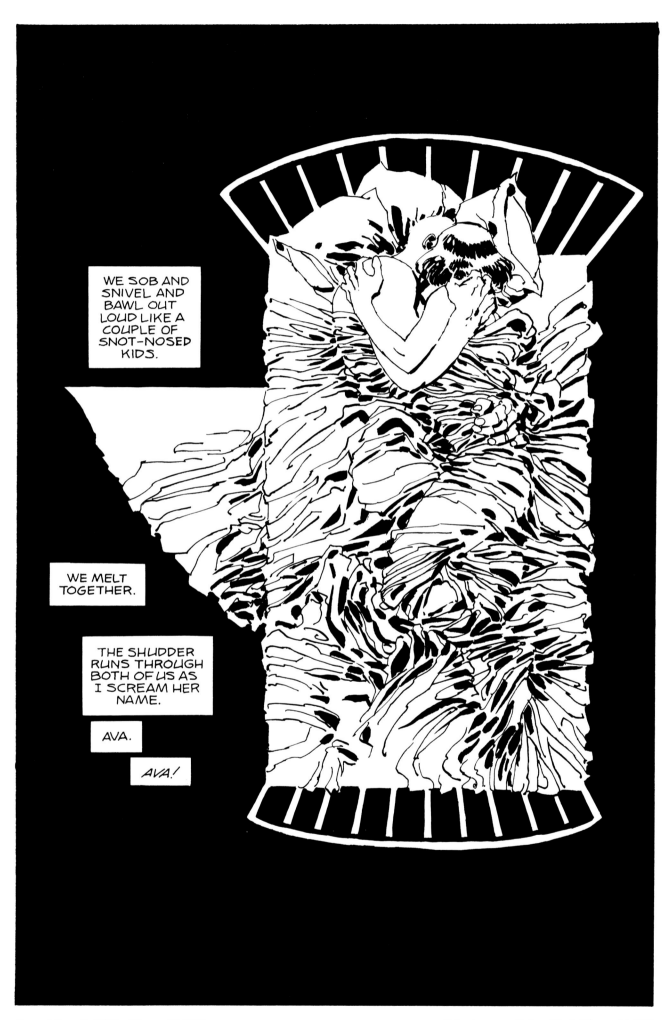

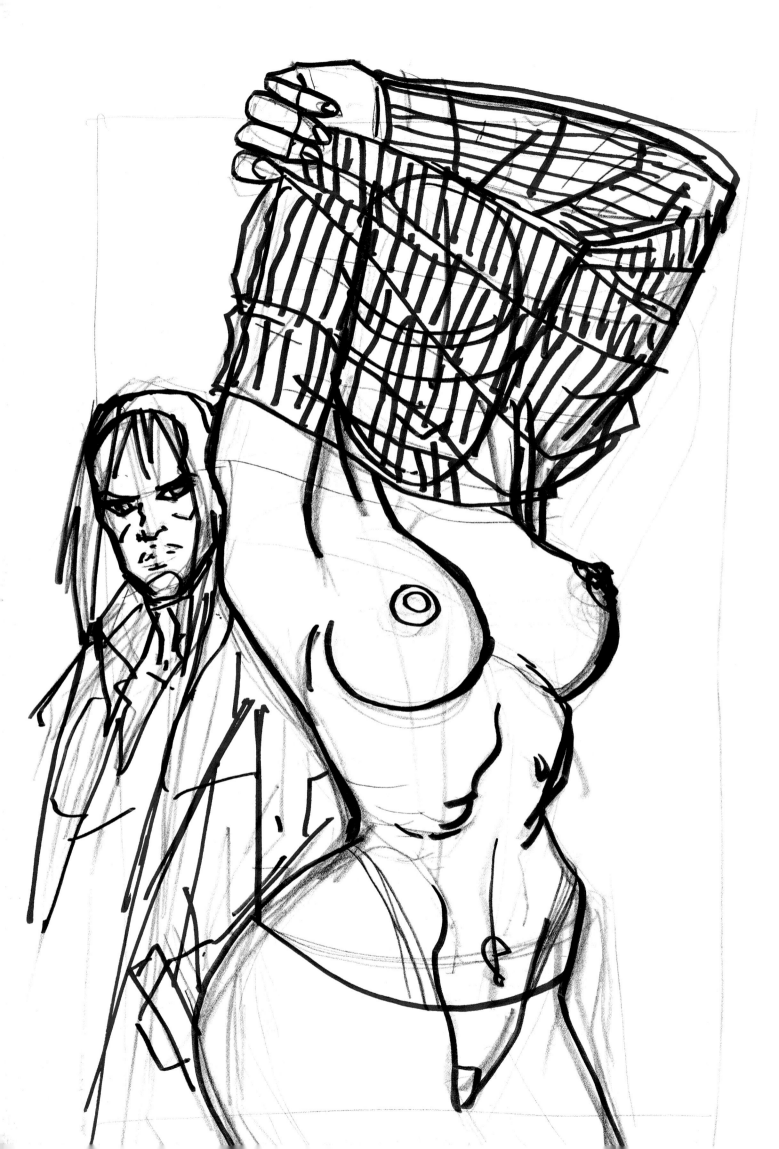

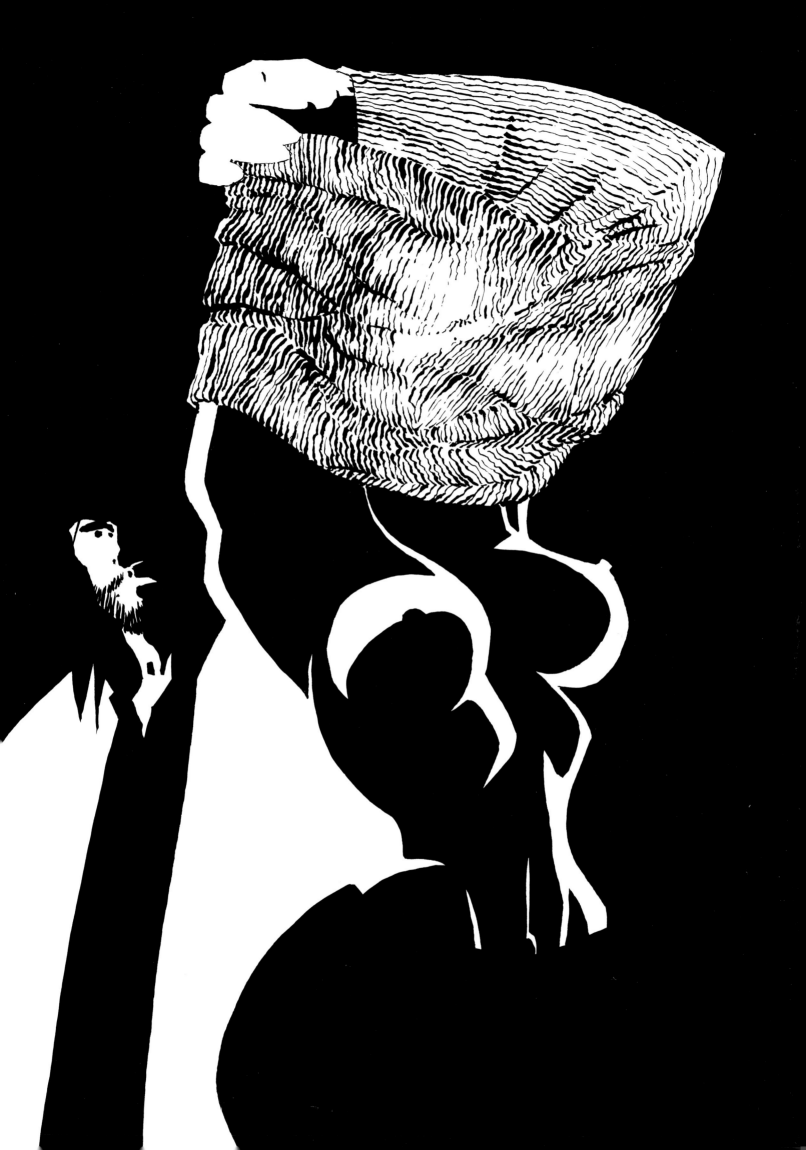

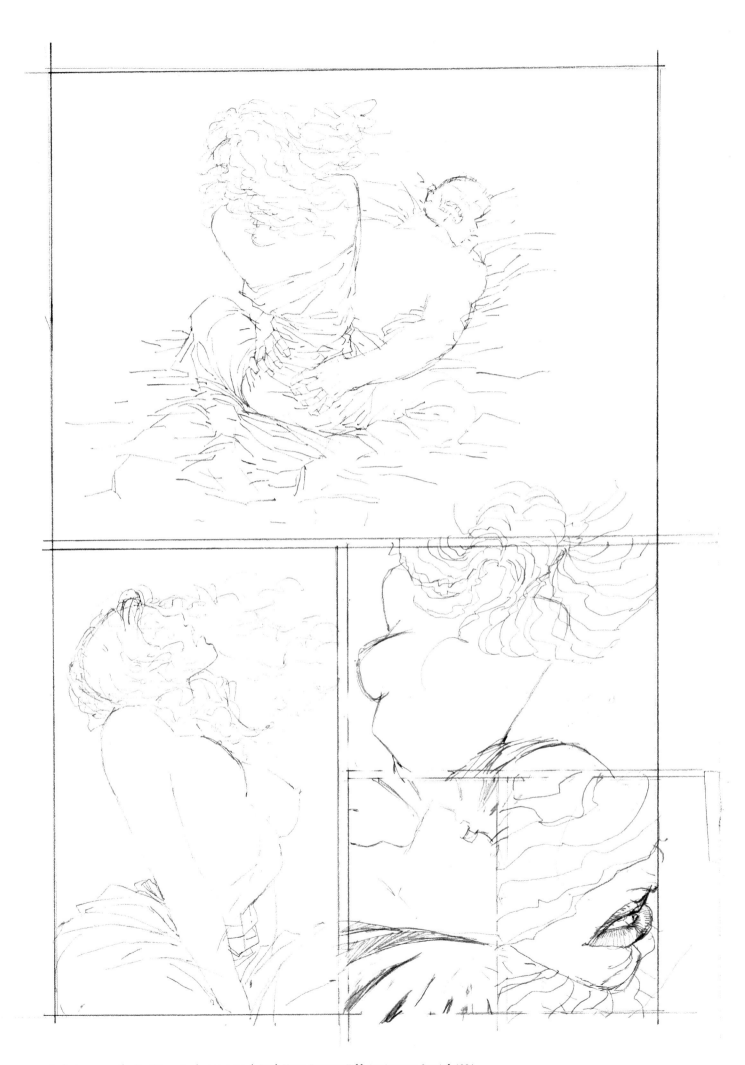

Preliminary pencils, *Sin City*, episode one, page 4, *Dark Horse Presents Fifth Anniversary Special*, 1991

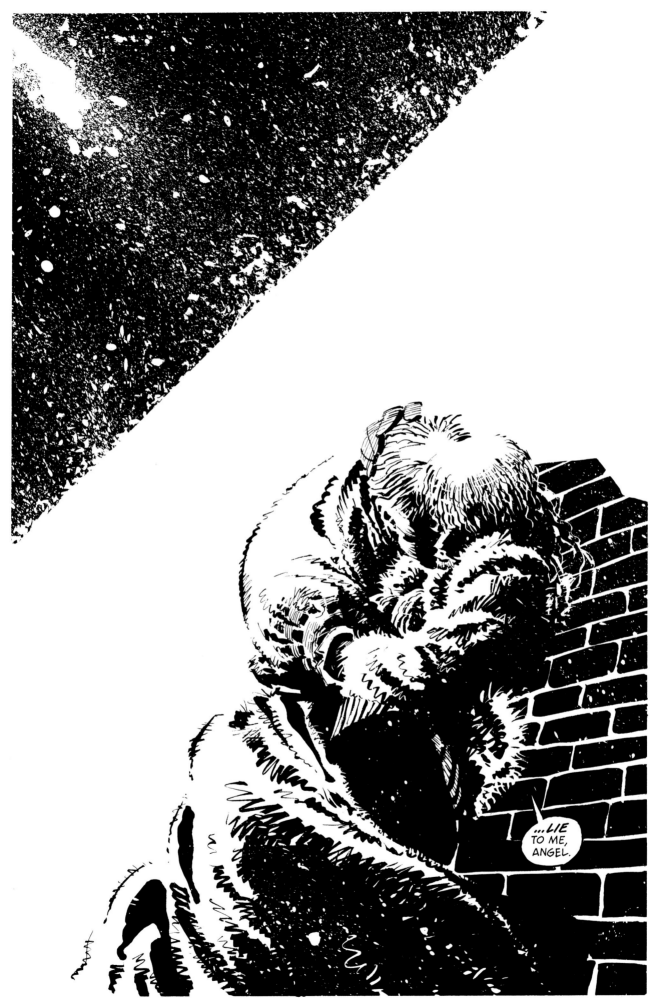

Above: *Family Values*, page 39, 1997

Following page: *Lost, Lonely, & Lethal*, front cover, 1996

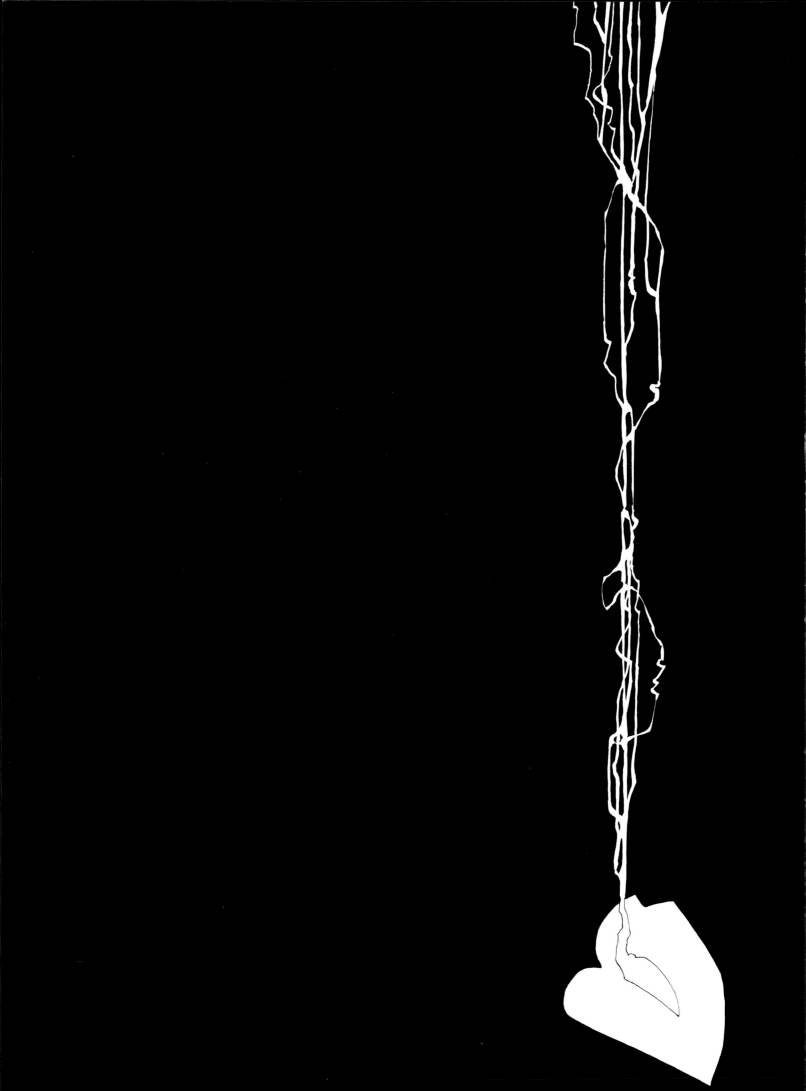

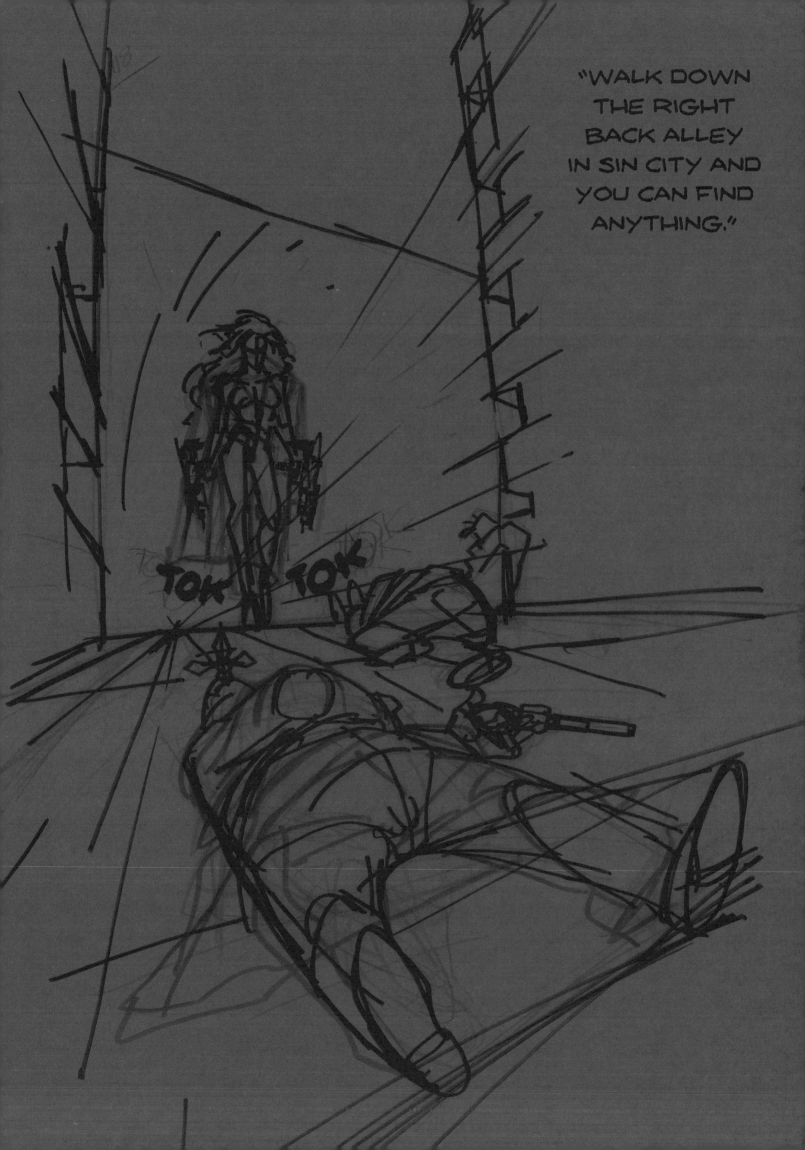

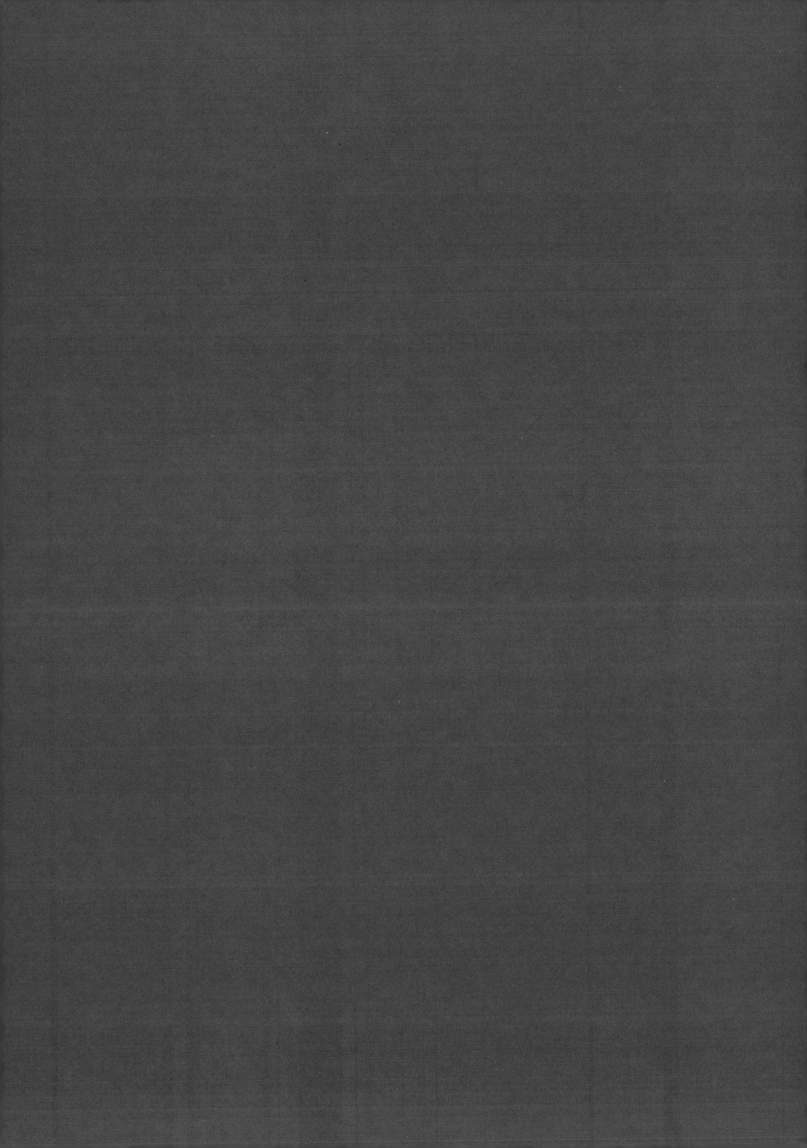

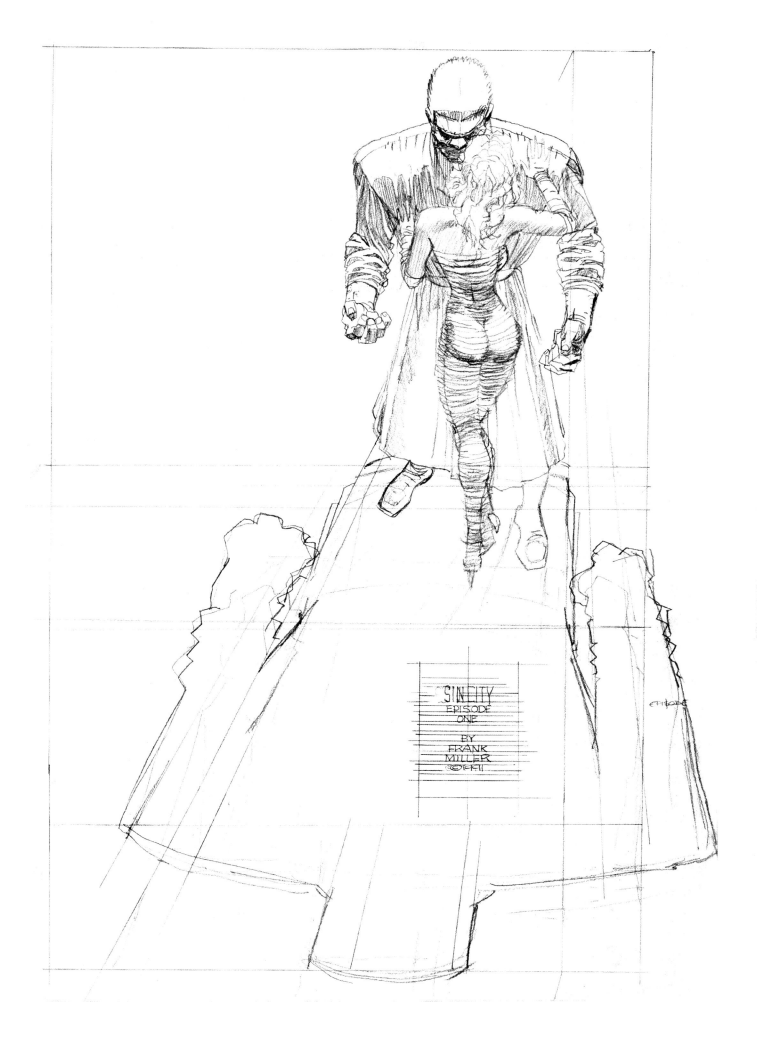

Preliminary pencils, *Sin City*, episode one, page 1, *Dark Horse Presents Fifth Anniversary Special*, 1991

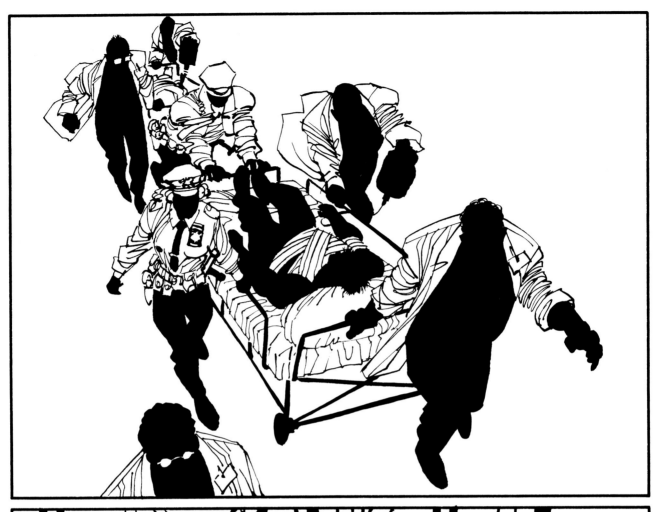

That Yellow Bastard #2, page 15, 1996

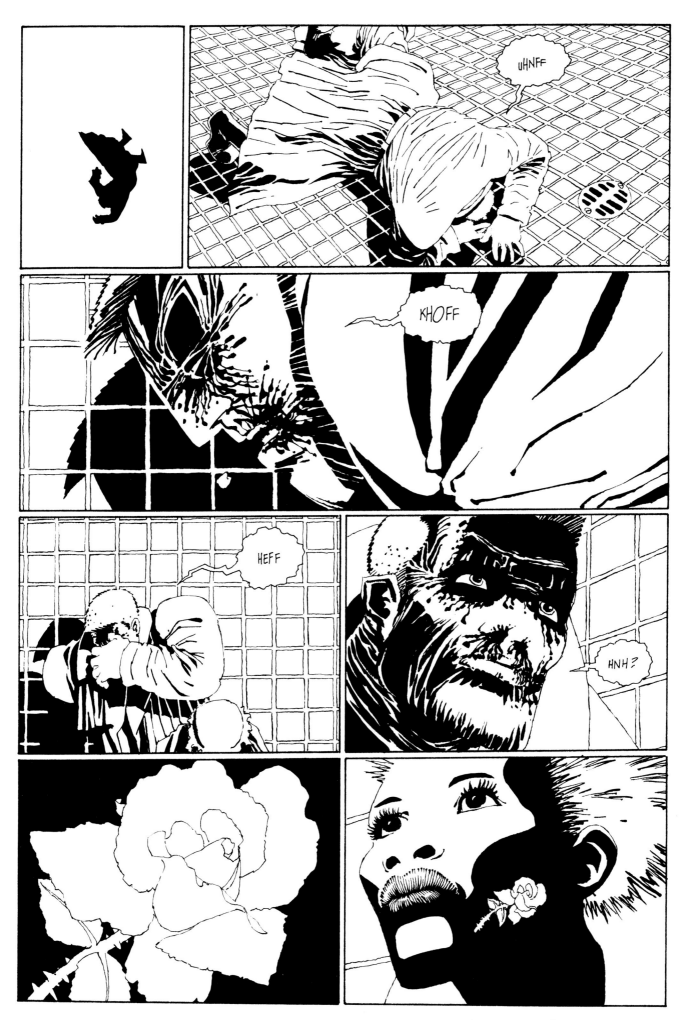

Sin City, episode nine, page 2, *Dark Horse Presents* #58, 1992

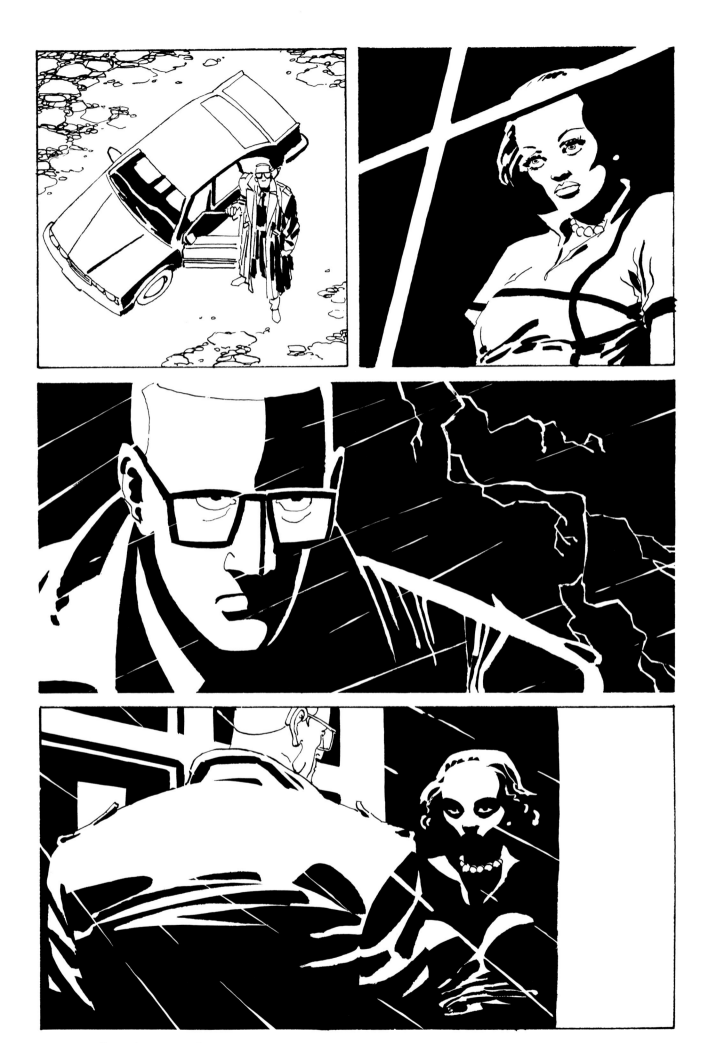

A Dame To Kill For #4, page 30, 1994

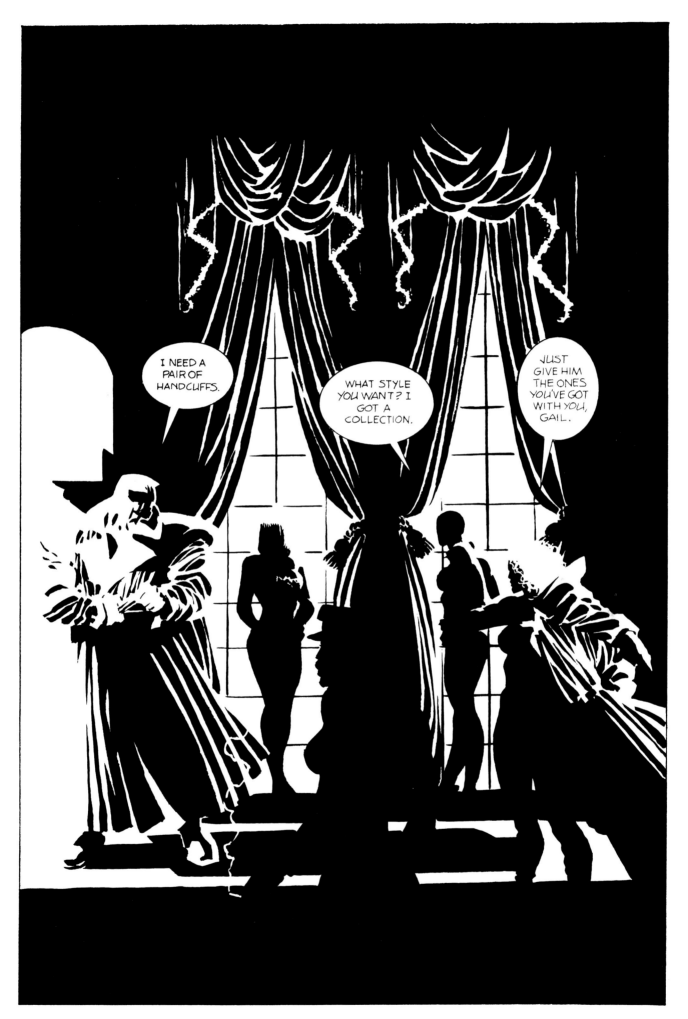

Above: *Sin City*, episode thirteen, page 3, *Dark Horse Presents* #62, 1992

Following page: *Family Values*, page 69, 1997

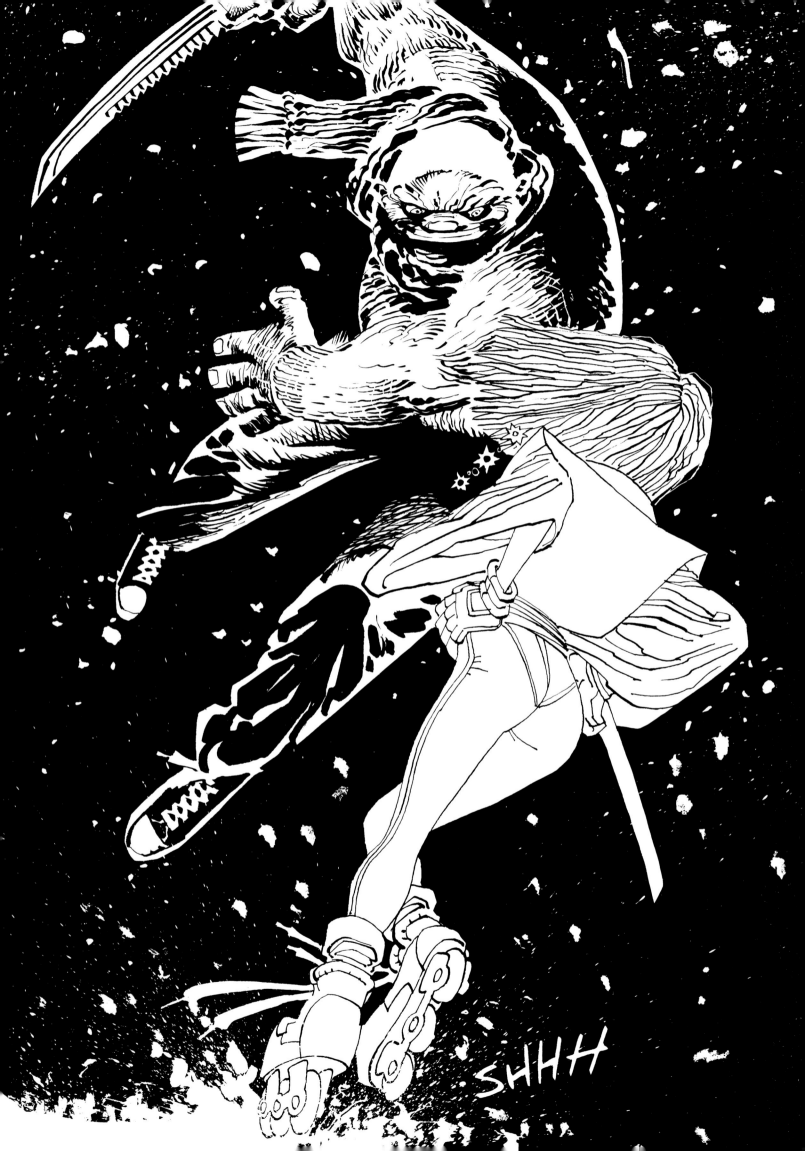

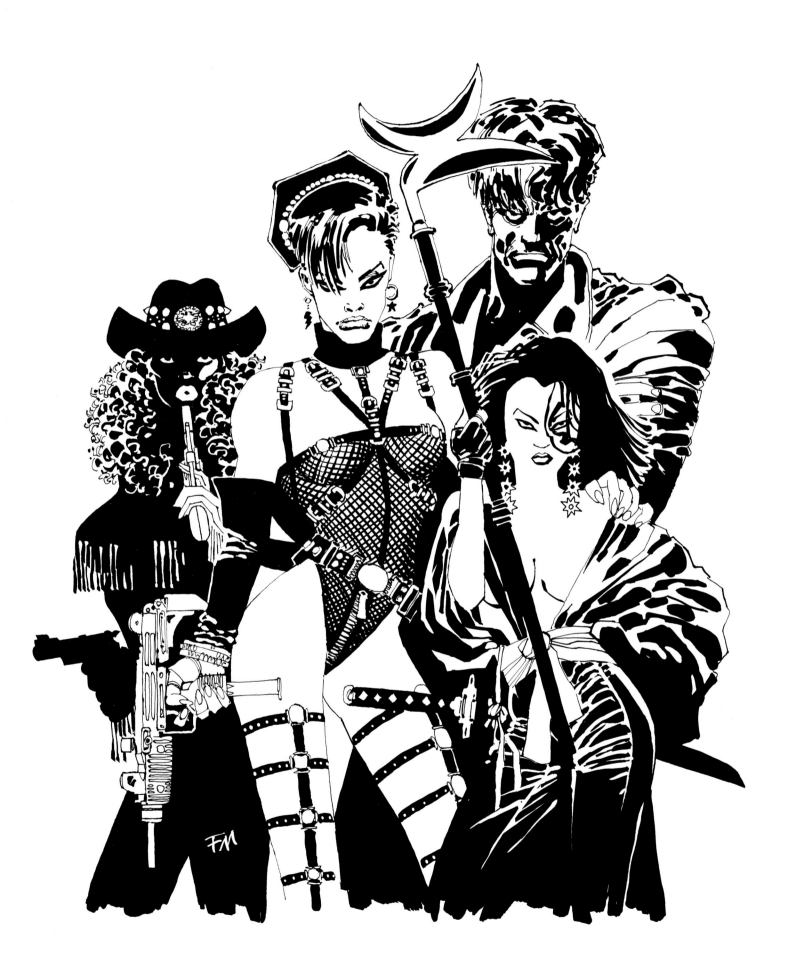

Above: *The Big Fat Kill* promotional art, 1994

Following spread: *The Big Fat Kill* #5, pages 36-37, 1995

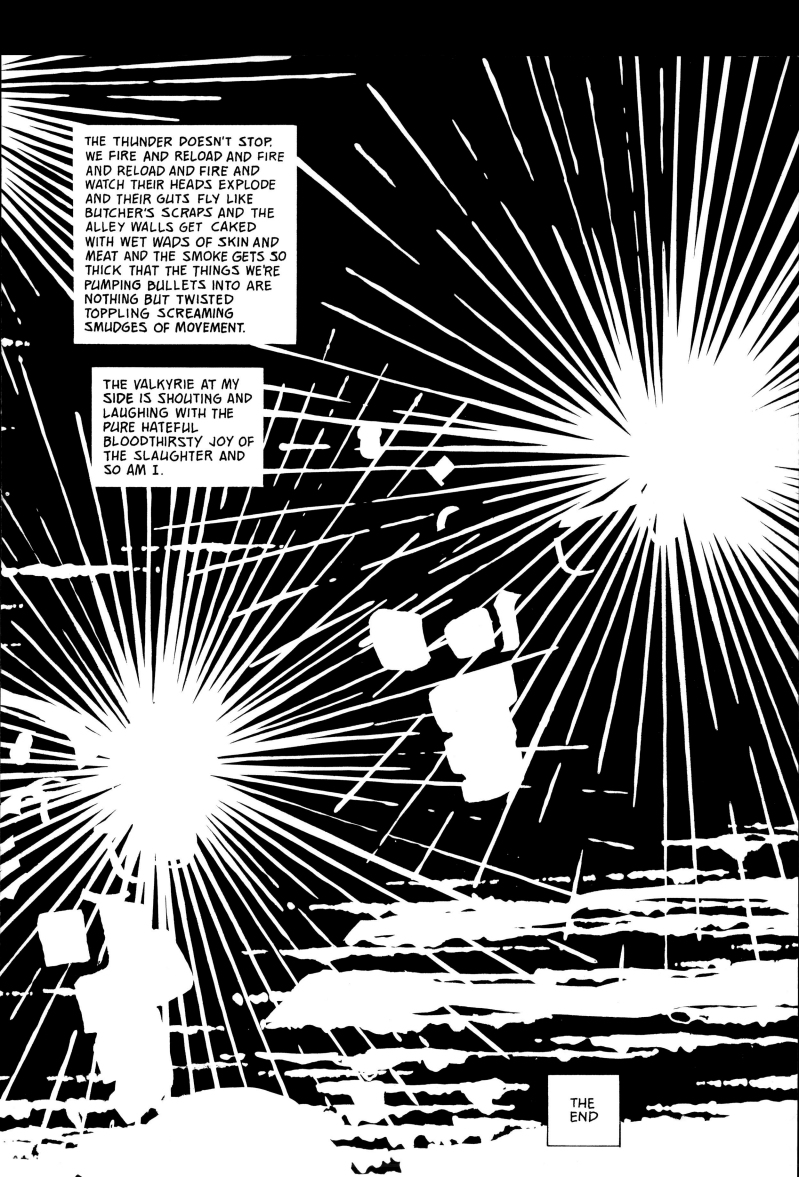

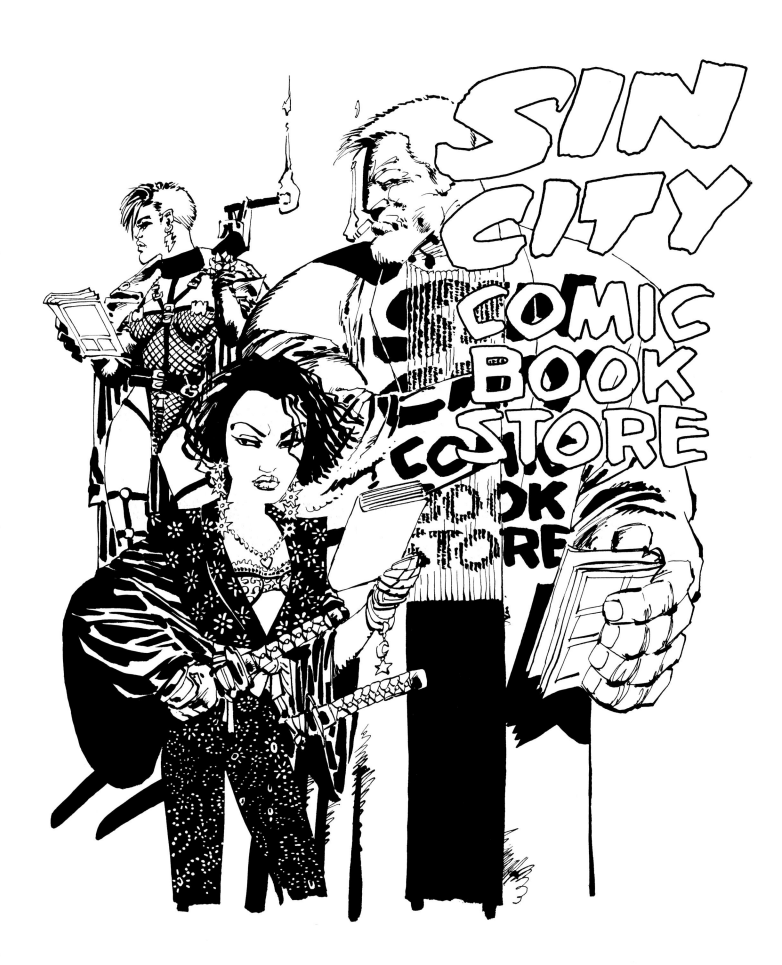

Above: *Free Speeches*, front cover, 1998

Opposite page: *Family Values*, page 41, 1997

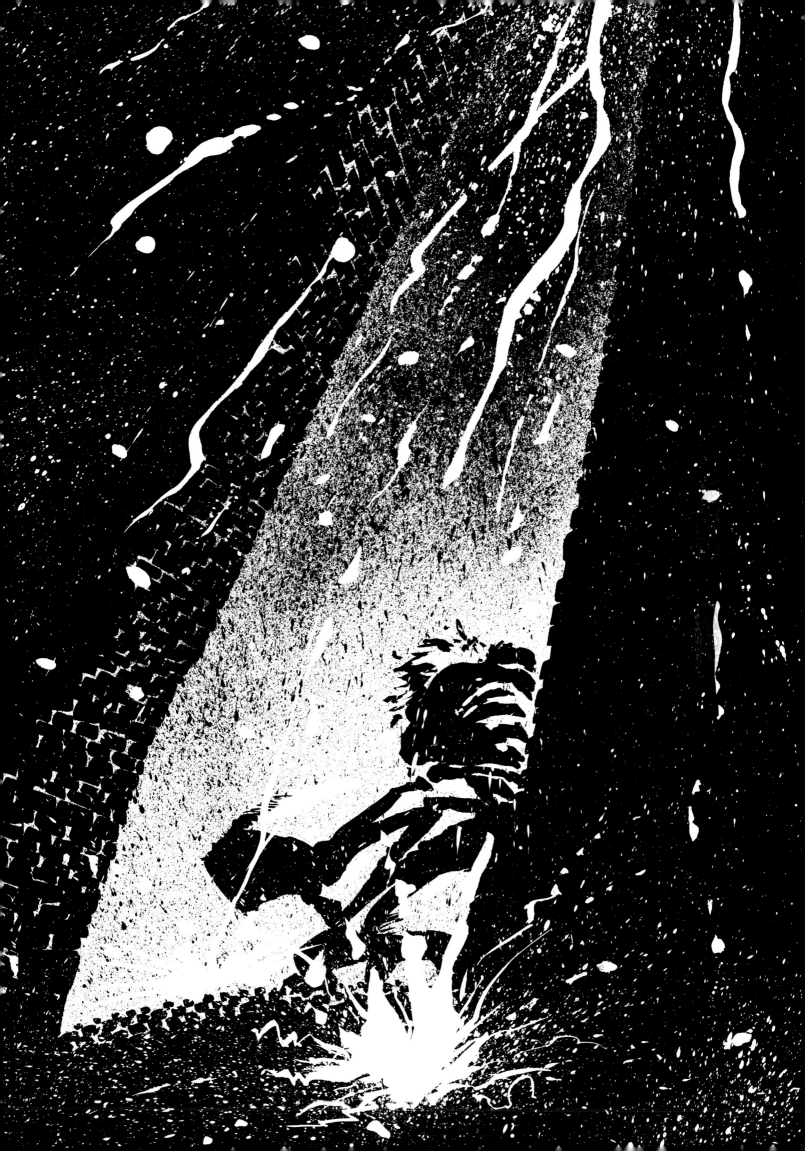

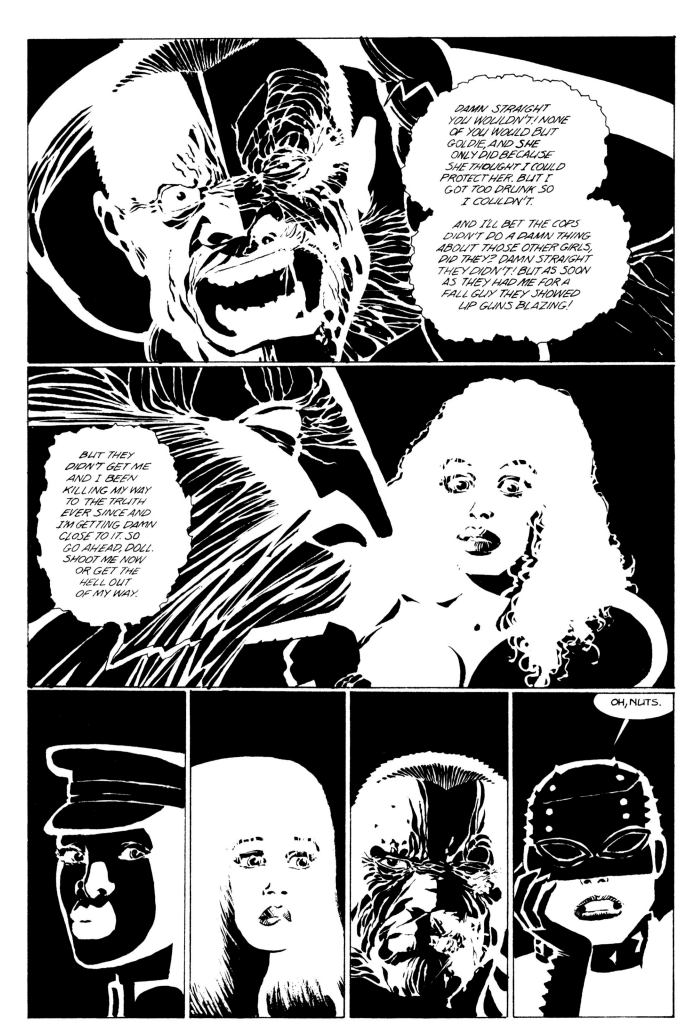

Sin City, episode twelve, page 7, *Dark Horse Presents #61*, 1992

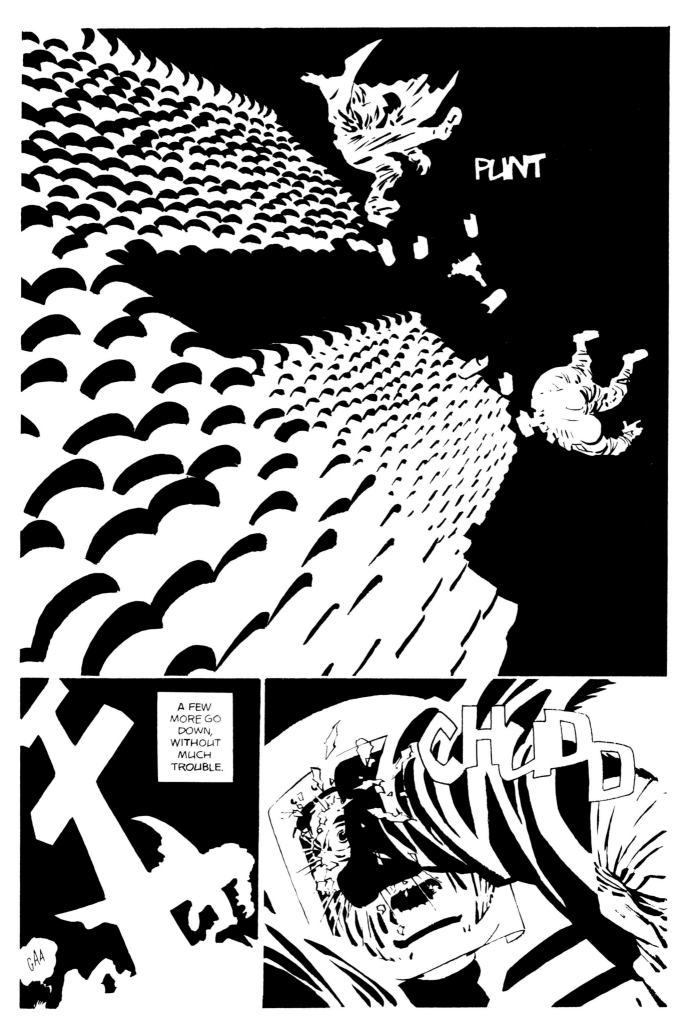

Sin City, episode thirteen, page 35, *Dark Horse Presents #62*, 1992

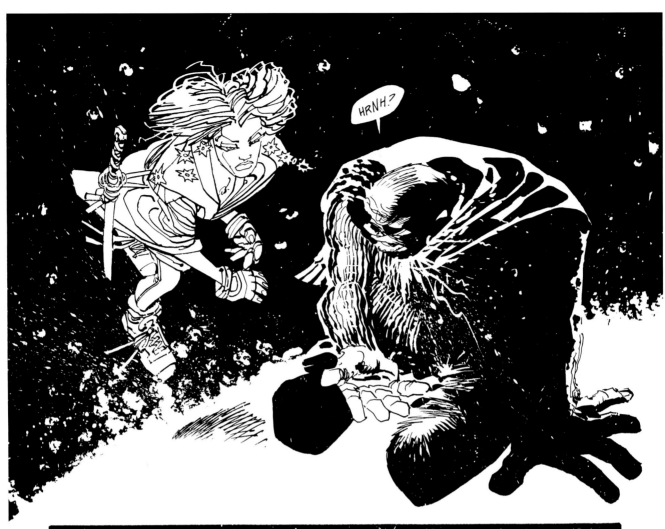

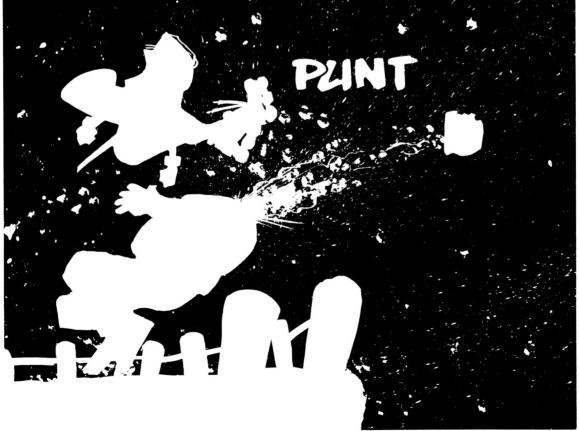

Family Values, page 84, 1997

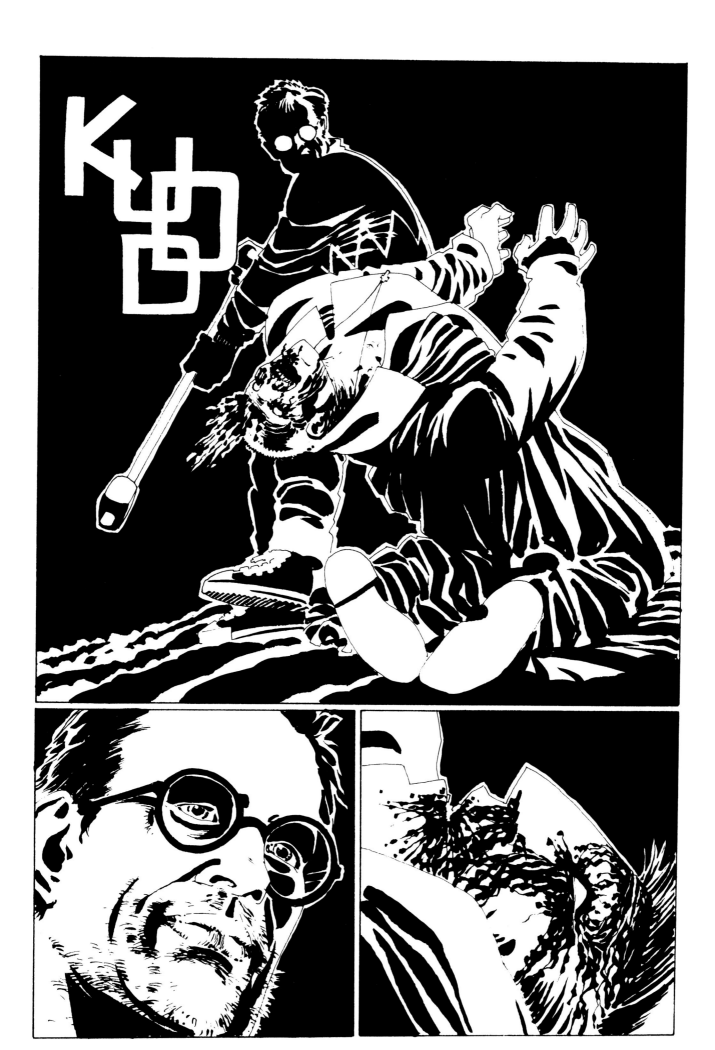

Sin City, episode eight, page 10, *Dark Horse Presents* #57, 1991

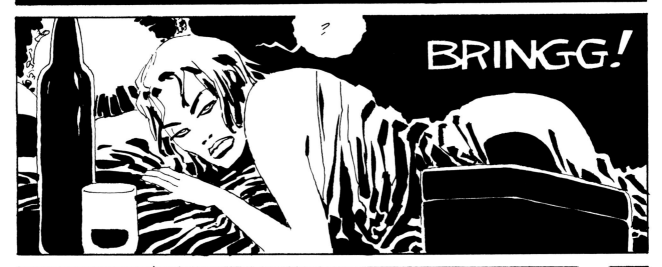

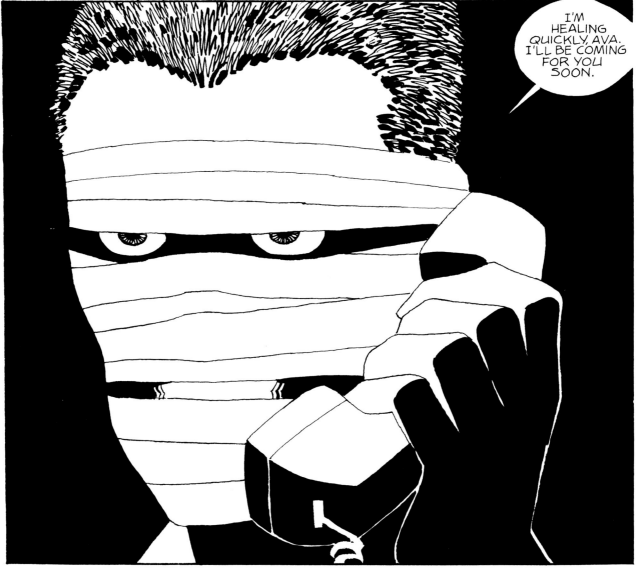

A Dame To Kill For #5, page 26, 1994

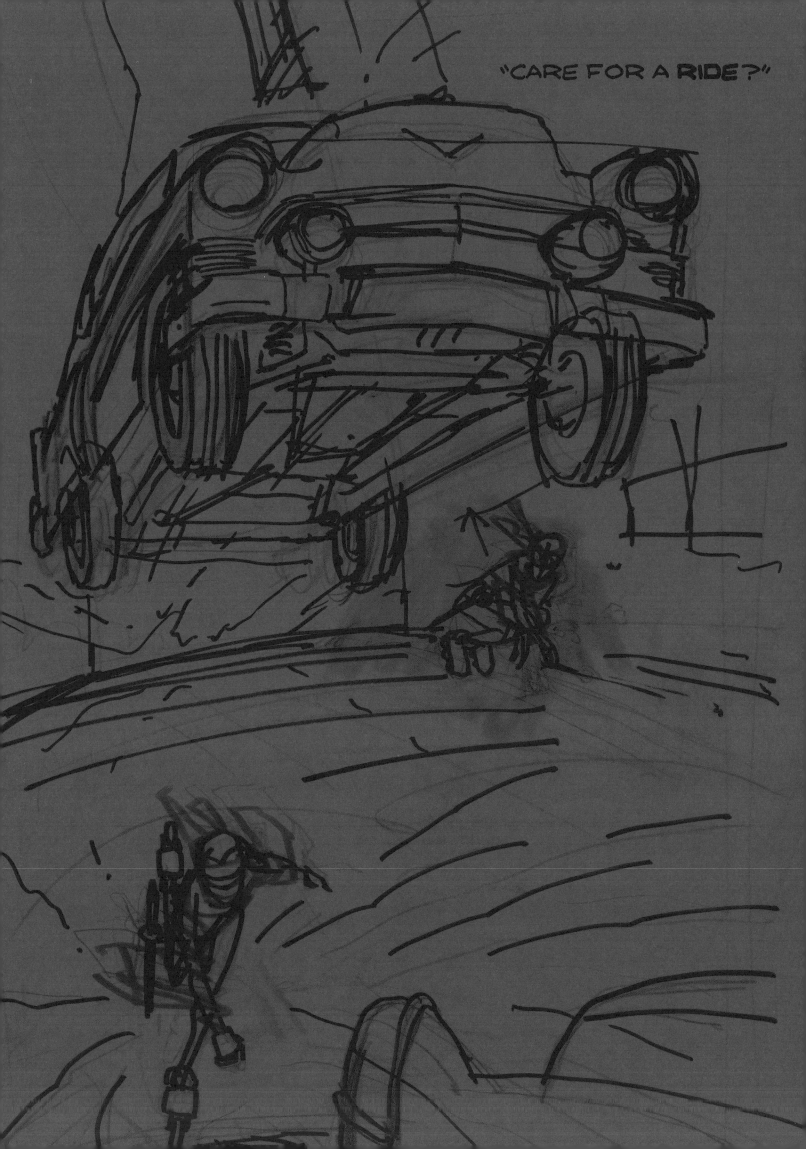

"CARE FOR A RIDE?"

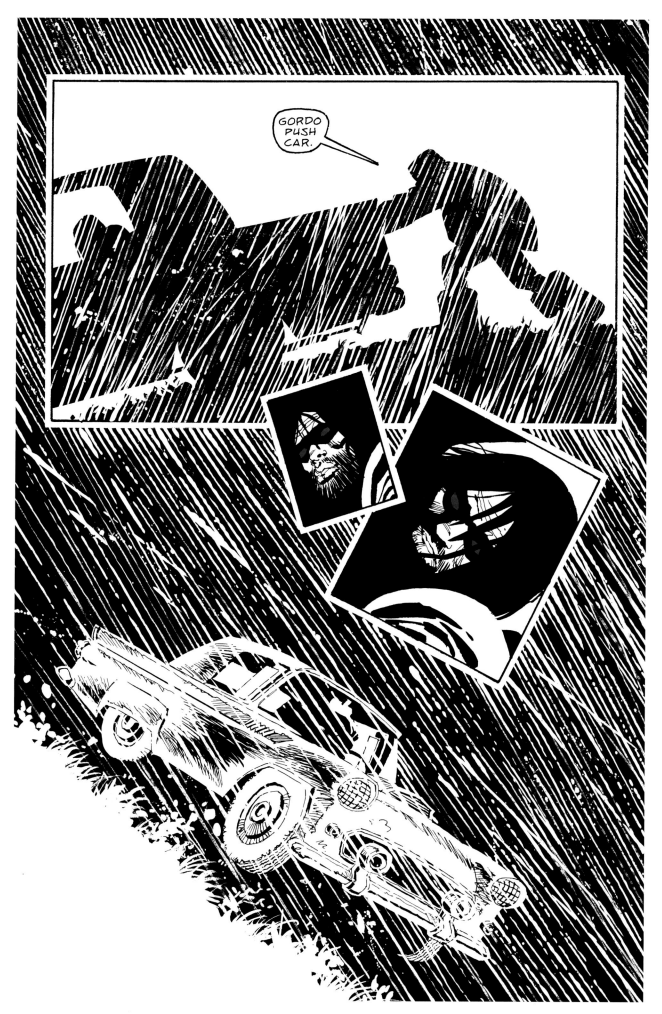

Hell and Back #6, page 27, 1999

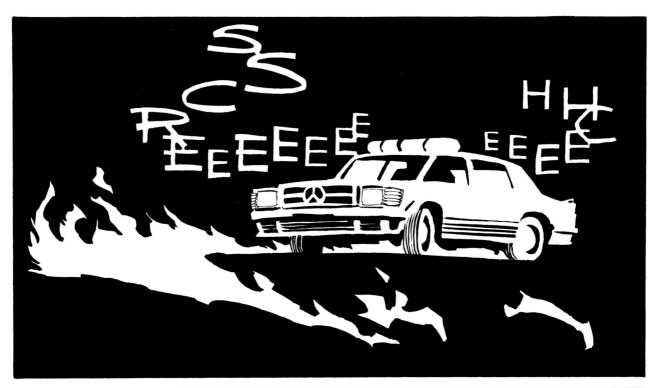

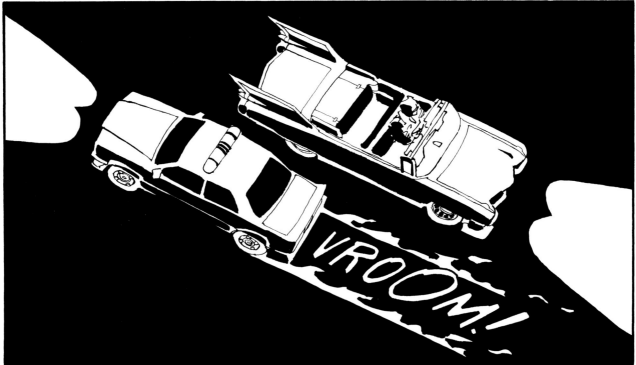

The Big Fat Kill #1, page 21, 1994

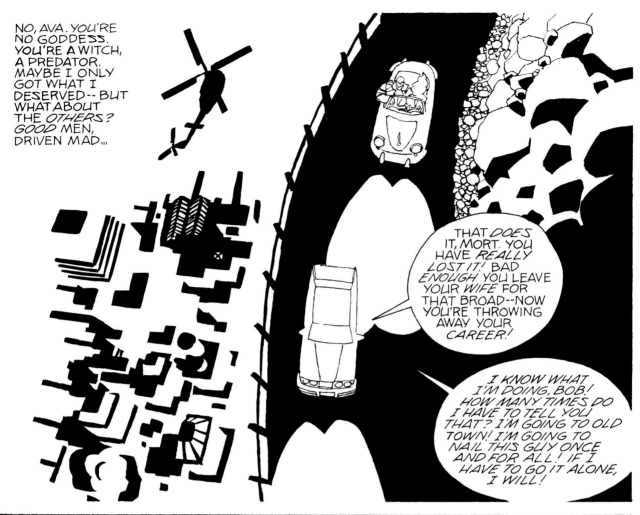

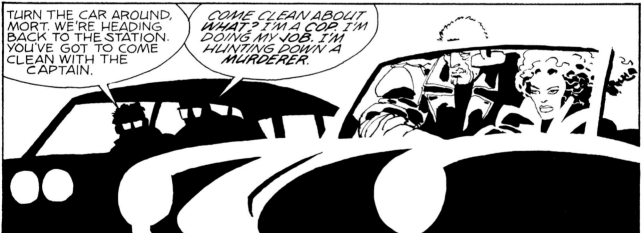

A Dame To Kill For #6, page 4, 1994

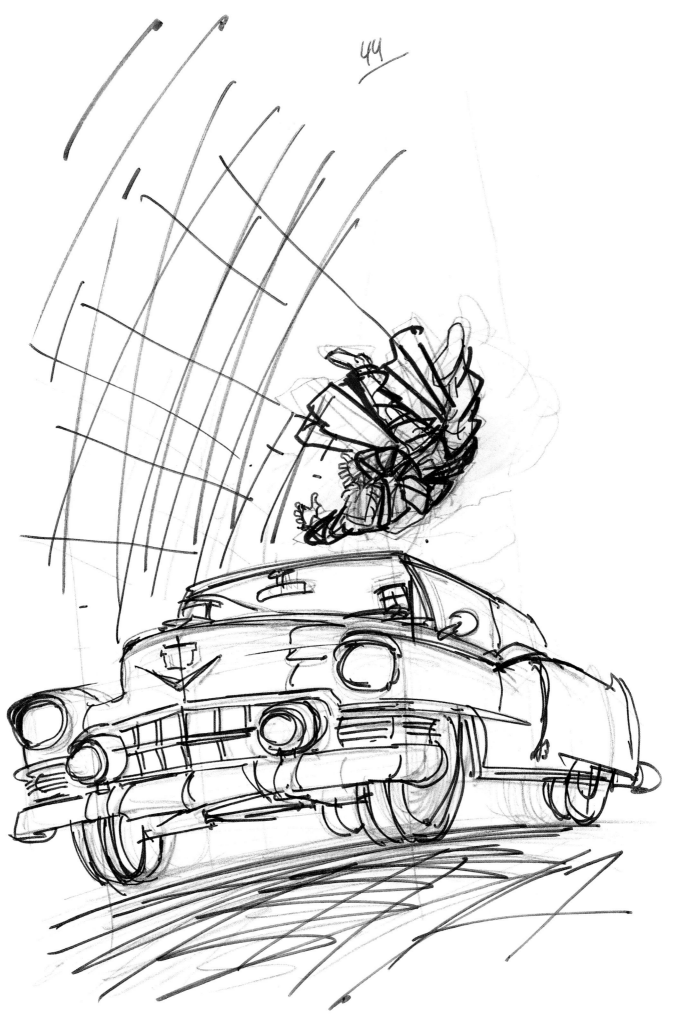

Above and opposite: *Family Values*, page 46, 1997

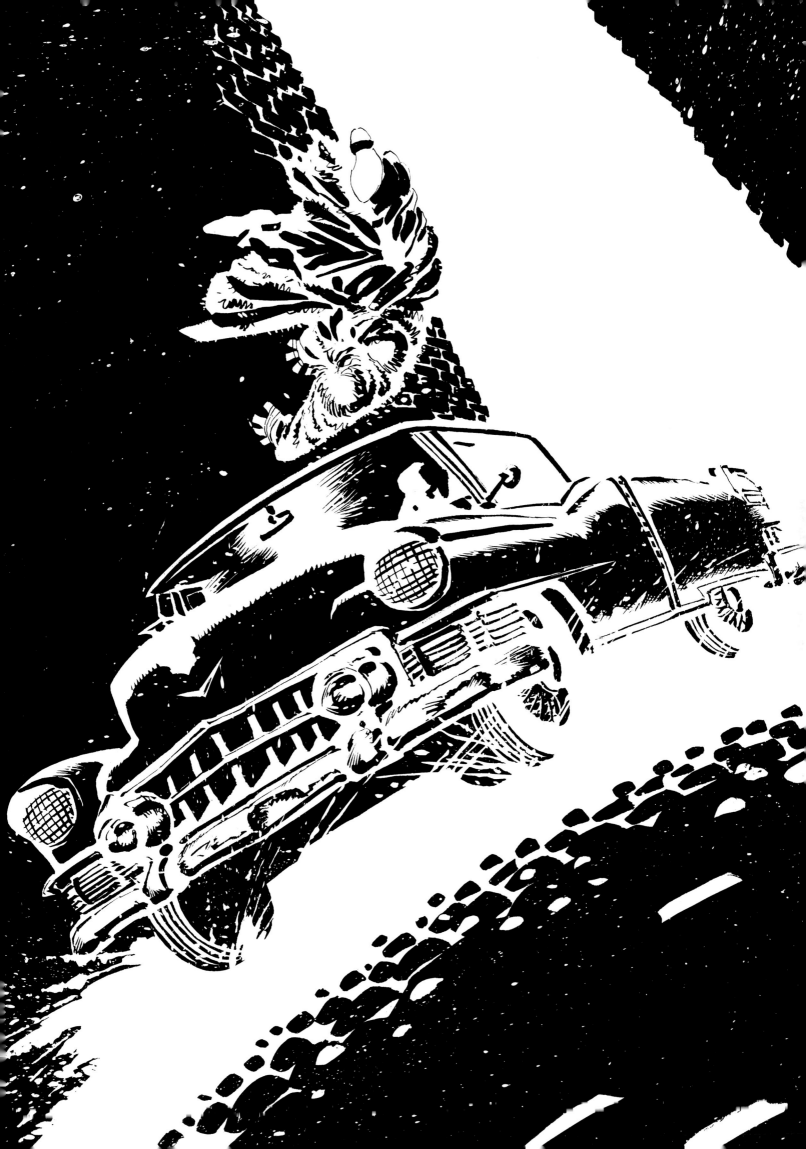

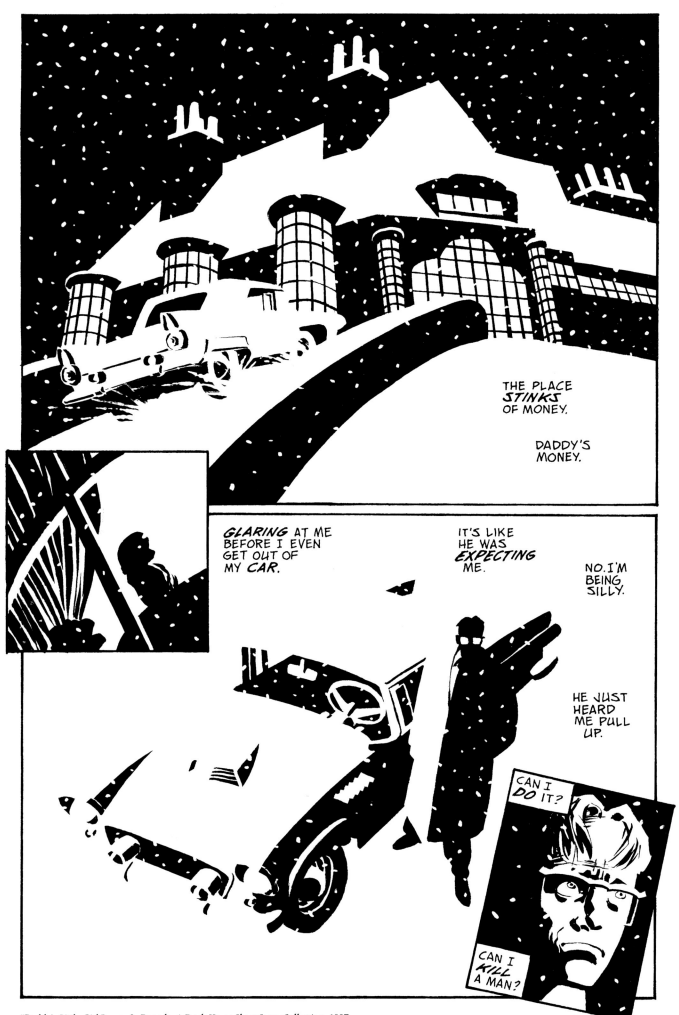

"Daddy's Little Girl," page 3, *Decade: A Dark Horse Short Story Collection*, 1997

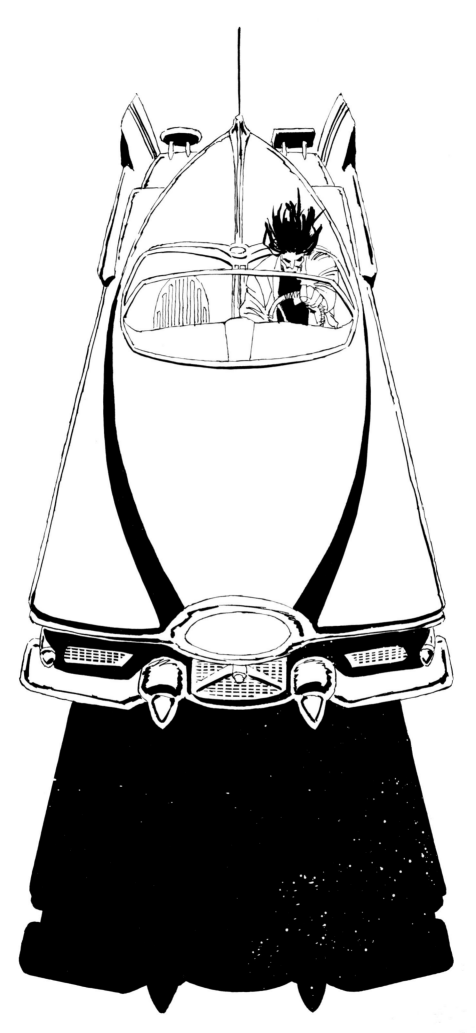

Hell and Back #3, page 26, 1999

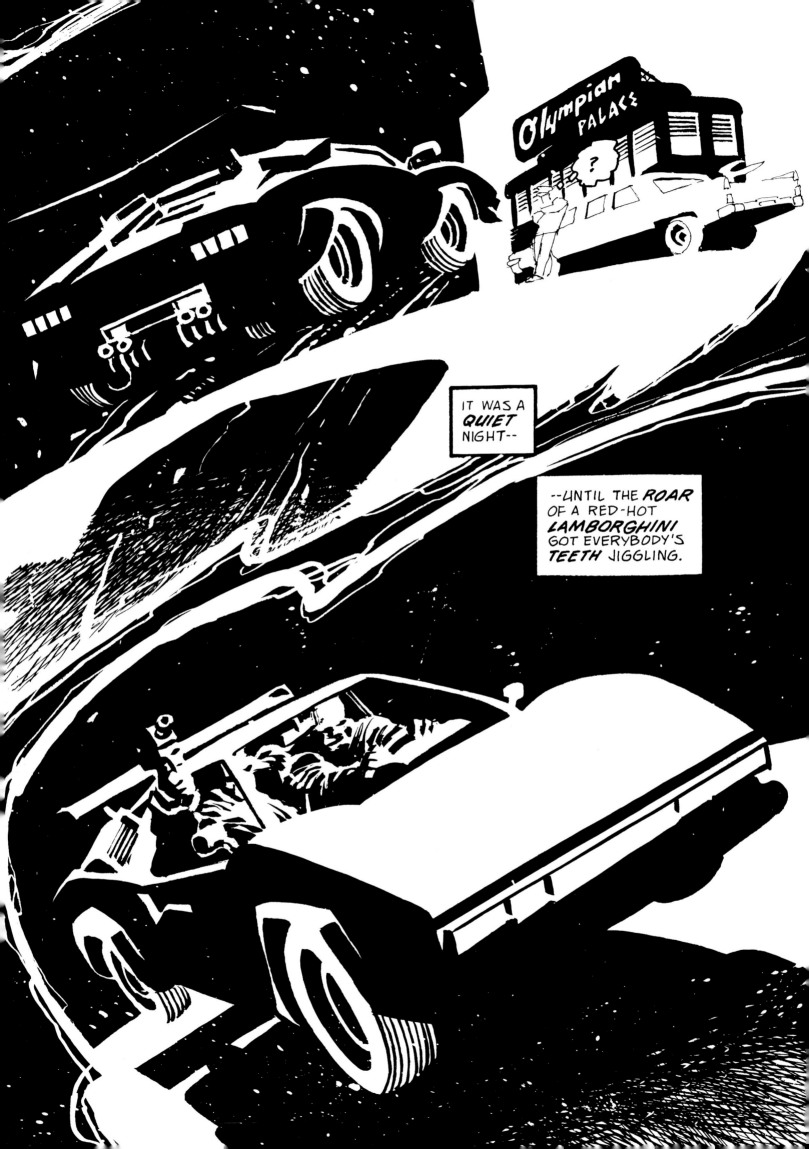

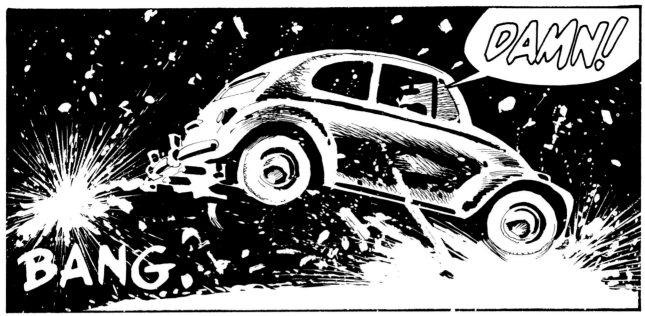

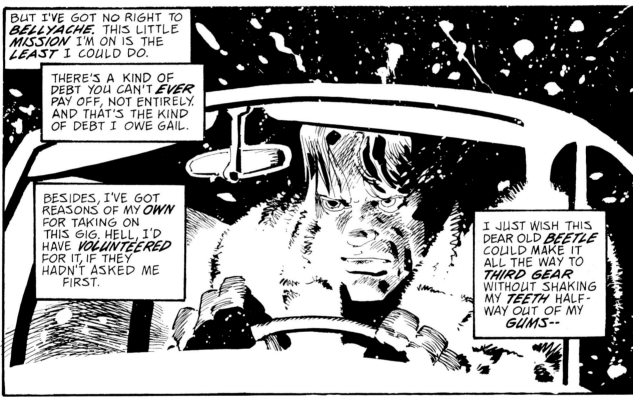

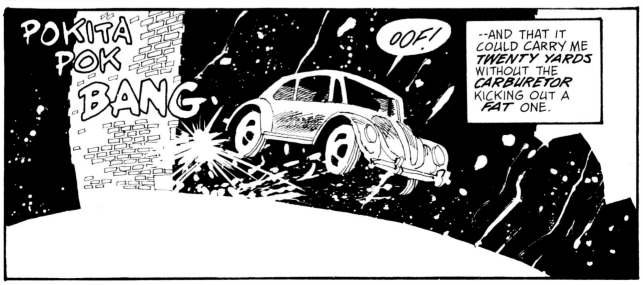

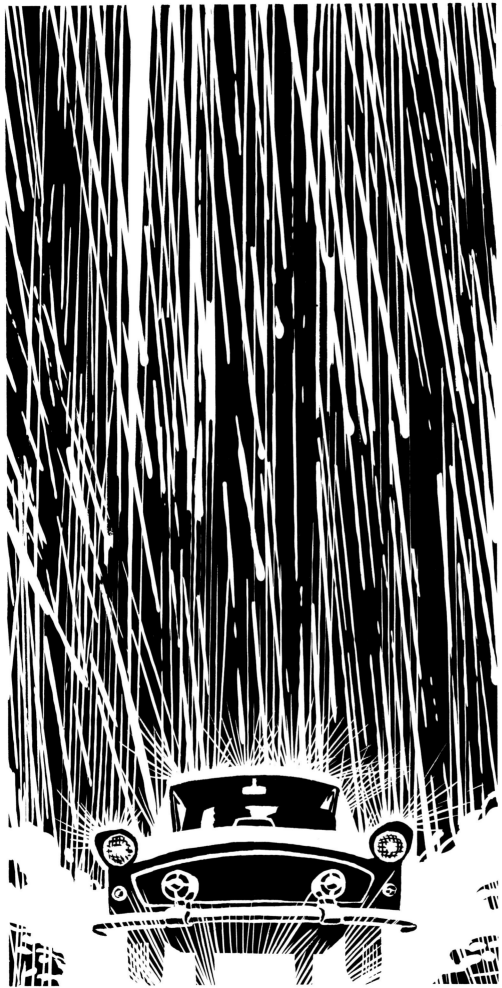

DIZZY DAMES. WHAT WERE THEY *THINKING,* STICKING ME WITH A BEAT-UP BUCKET OF BOLTS LIKE THIS? SOMEBODY OUGHTTA TAKE IT OUT BACK AND *SHOOT* IT. IT'D BE A *MERCY.*

A FEW YEARS BEFORE I WAS *BORN,* THIS T-BIRD MUST'VE BEEN A PRETTY SWEET SET OF WHEELS. BUT IT'S BEEN AROUND A FEW TOO MANY BLOCKS A FEW TOO MANY TIMES AND WHOEVER OWNED IT OBVIOUSLY DIDN'T INDULGE IN LUXURIES LIKE THE OCCASIONAL TUNE-UP OR OIL CHANGE. THE ENGINE JERKS AND FARTS LIKE AN OLD MAN ON A BAD DIET. THE STEERING MECHANISM'S GOT TERMINAL ARTHRITIS. THE SUSPENSION MAKES EVERY POTHOLE AN ADVENTURE. THE LEFT REAR TIRE IS AS SOFT AS A ROTTEN BANANA AND IF THAT'S A SLOW LEAK I'M GOOD AND SCREWED. I HAD TO CHUCK THE SPARE TO MAKE ROOM FOR ALL THE NEATLY CHOPPED BODY PARTS WE PACKED IN THE TRUNK.

MAYBE FIVE BLOCKS OUT I HAPPEN TO GLANCE DOWN AT THE GAS GAUGE. WHAT I SEE GETS ME POUNDING MY FISTS AGAINST THE STEERING WHEEL LIKE SOME LUNATIC. I CURSE OUT EVERY GIRL WHO EVER WORKED OLD TOWN AND EVERY RELATIVE ANY OF THEM EVER HAD.

HOW THE HELL AM I SUPPOSED TO MAKE IT ALL THE WAY TO THE PITS AND BACK ON LESS THAN AN EIGHTH OF A TANK.?

DIZZY DAMES! DIZZY, SCARED, STUPID DAMES! YOU COULDN'T BOTHER TO FILL THE GOD DAMN GAS TANK.?

The Big Fat Kill #3, page 11, 1995

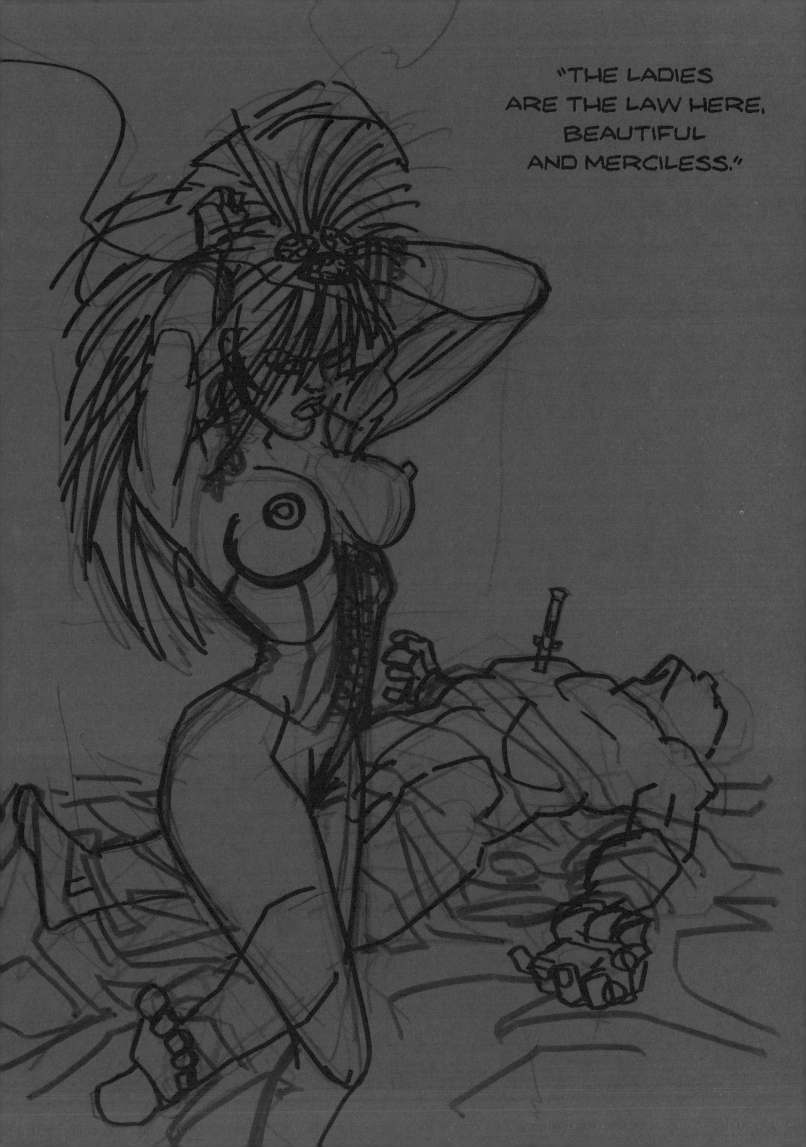

"THE LADIES
ARE THE LAW HERE,
BEAUTIFUL
AND MERCILESS."

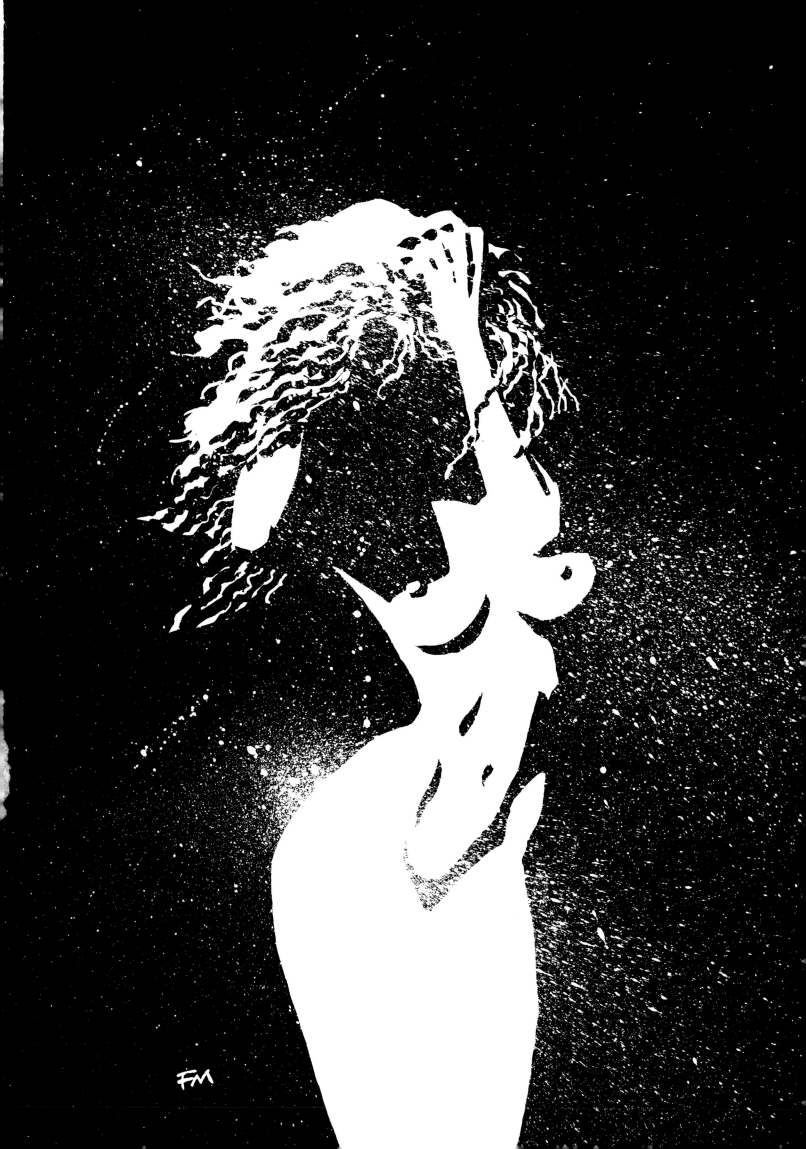

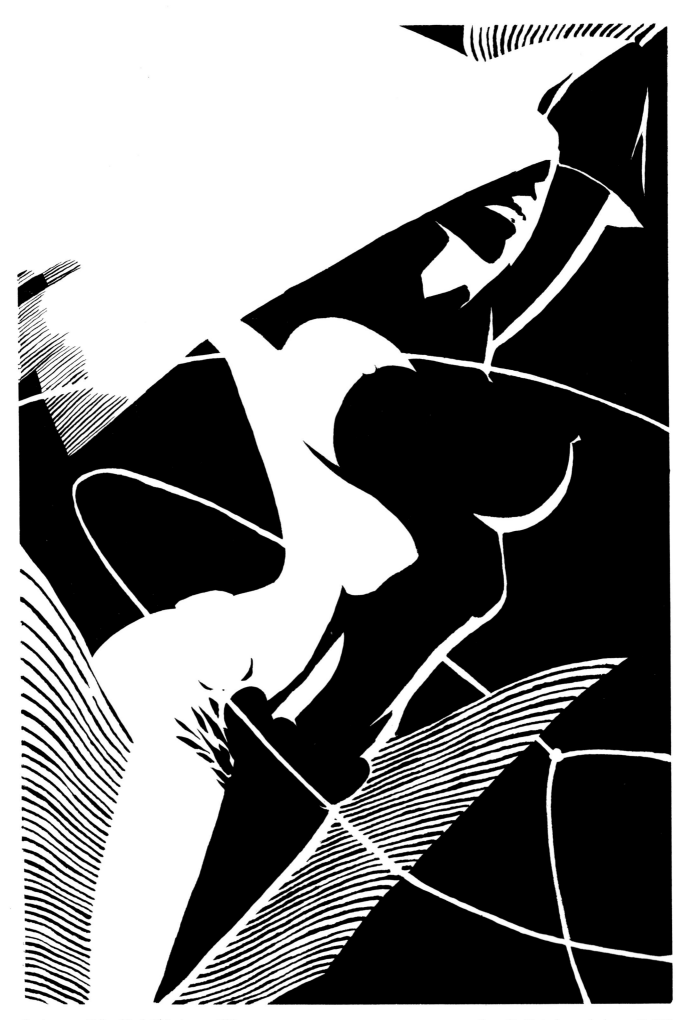

Previous page: *Hell and Back* #6, back cover, 1999

Above: *Sin City* trade paperback, page 57, 1993

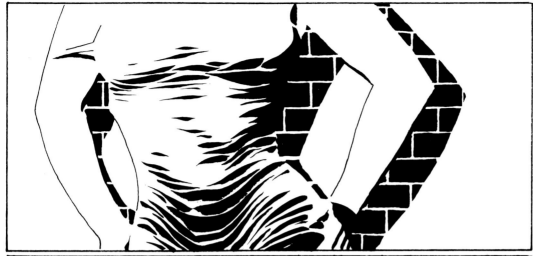

THE RAIN'S SPUTTERED TO A STOP AND THE STREETS HAVE COME BACK TO LIFE BY THE TIME I MAKE MY WAY TO OLD TOWN.

THE MERCHANDISE IS ON DISPLAY, NEVER MIND THE COLD. PRETTY SOON EVERYTHING FROM PICKUPS TO LIMOS WILL BE PULLING IN AND BUSINESS WILL BE BOOMING.

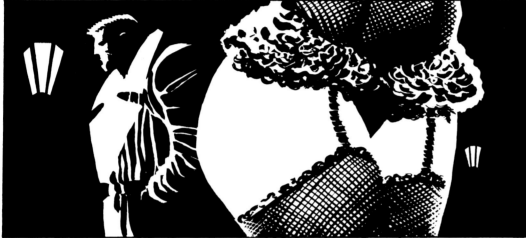

OLD TOWN IS WHY NOBODY CALLS THIS BURG "BASIN CITY" LIKE IT SAYS ON THE MAPS.

IT WAS SAINT PATRICK'S GREAT-GRANDFATHER WHO MADE IT HAPPEN. BACK THEN THIS WAS A GOLD RUSH TOWN ON ITS WAY TO BECOMING A GHOST TOWN.

THEN OLD MAN ROARK GOT HIMSELF AN IDEA.

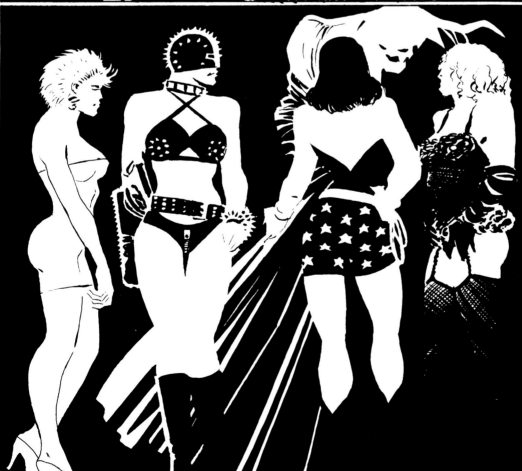

HE SPENT EVERY SILVER DOLLAR HE HAD, IMPORTING TOP HOOKERS FROM FRANCE AND PLACES LIKE THAT.

WORD GOT OUT AND PRETTY SOON SIN CITY WAS THE HOTTEST STOP IN THE WEST. PEOPLE WOULD COME FROM MILES AROUND.

THEY STILL DO AND IT'S EASY TO SEE WHY. OLD TOWN'S KEPT ITS TRADITIONS, HANDED DOWN FROM GORGEOUS MOTHER TO GORGEOUS DAUGHTER.

FOR AN HOUR OR SO I ASK AROUND ABOUT GOLDIE. I DON'T GET ANY ANSWERS BUT I KNOW I'M BOUND TO. LUCILLE SAID GOLDIE WAS A HOOKER AND IF SHE WAS, SHE HAS ROOTS HERE. FRIENDS.

MAYBE EVEN FAMILY.

Sin City, episode eleven, page 11, *Dark Horse Presents* #60, 1992

SIN CITY DAMES. AIN'T
NOTHING LIKE THEM
NOWHERE.

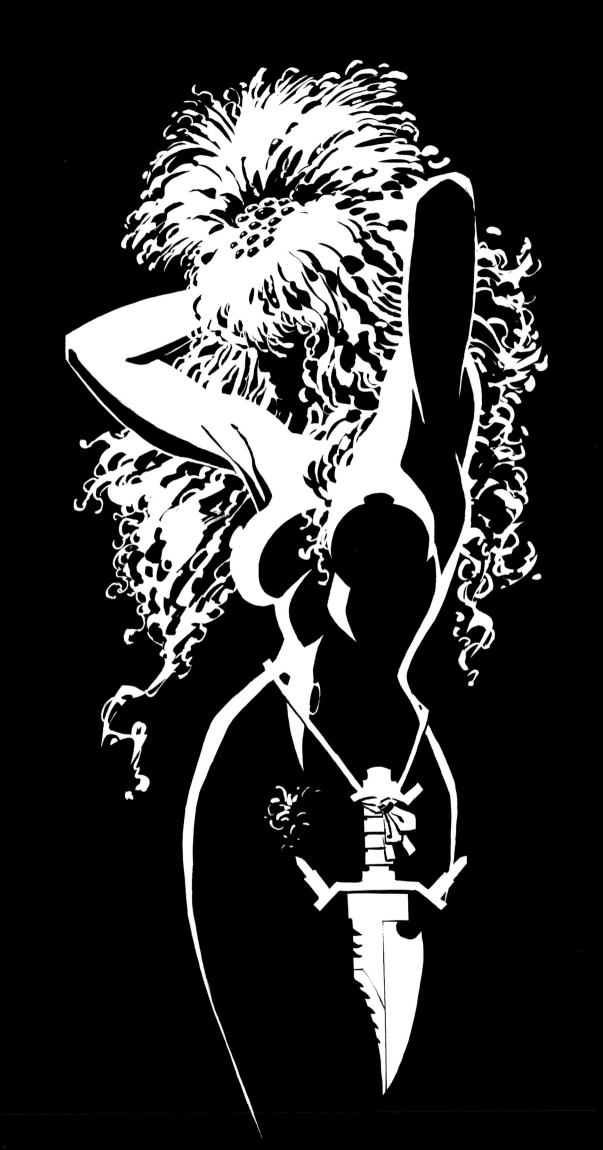

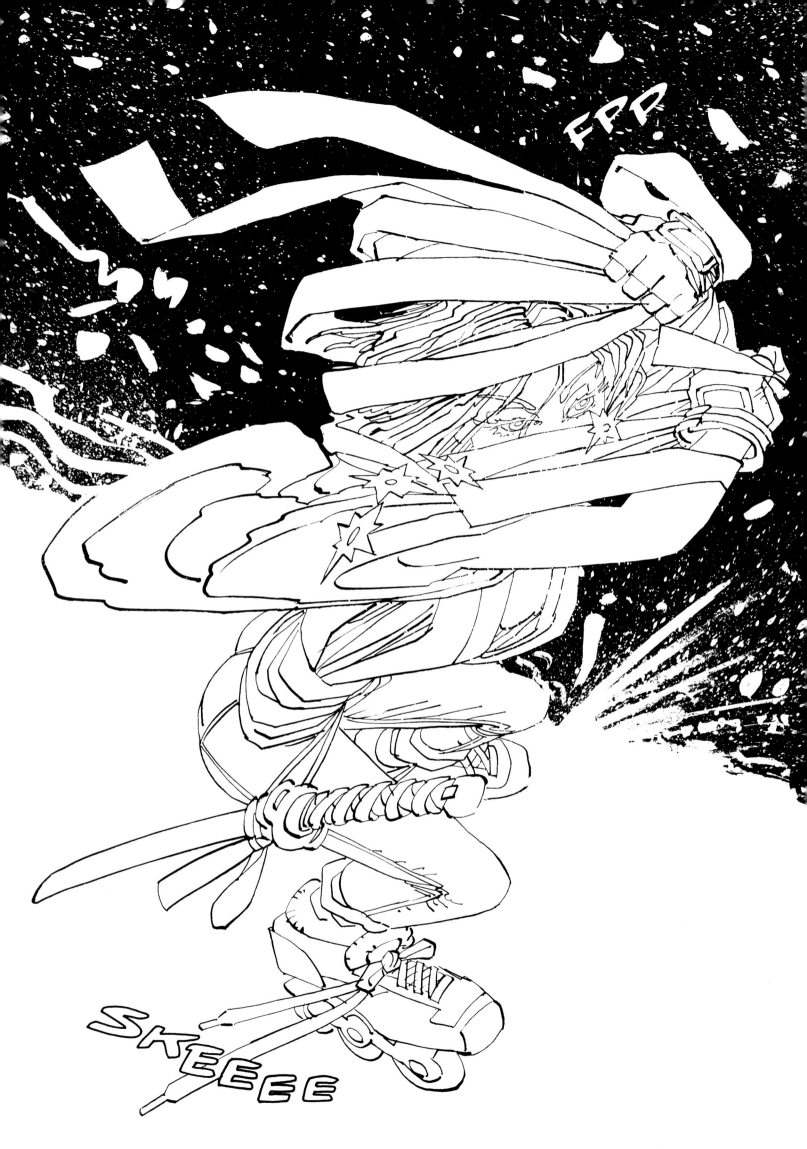

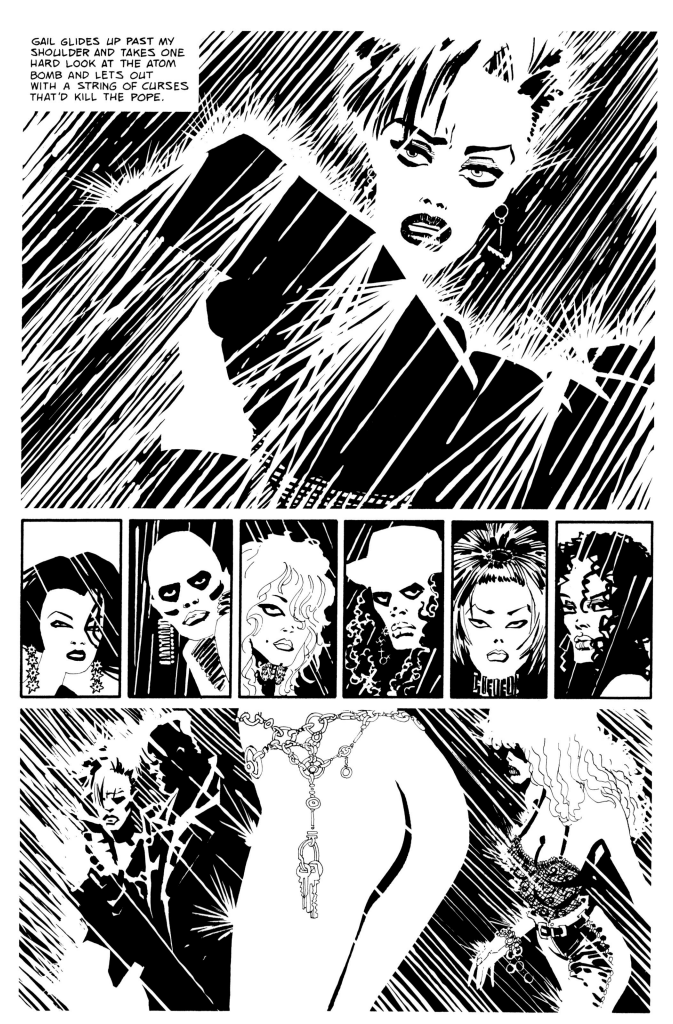

Opposite page: *Family Values*, page 57, 1997

Above: *The Big Fat Kill #2*, page 24, 1994

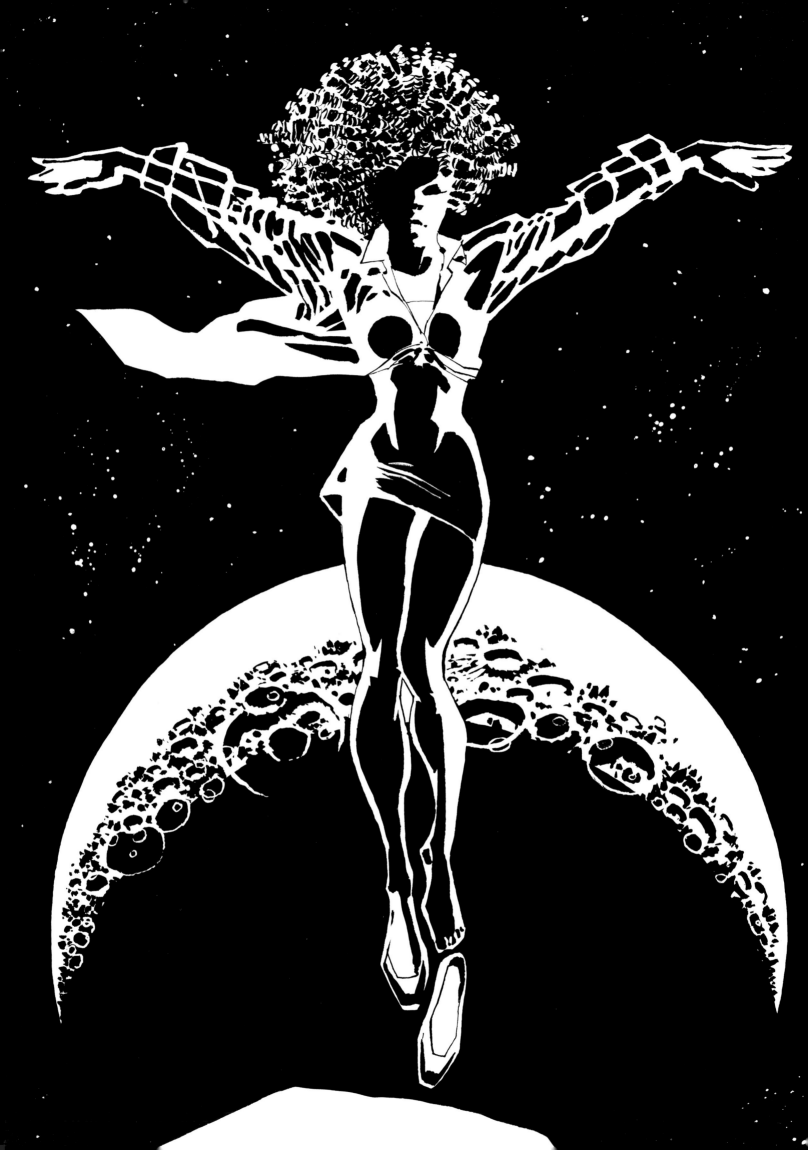

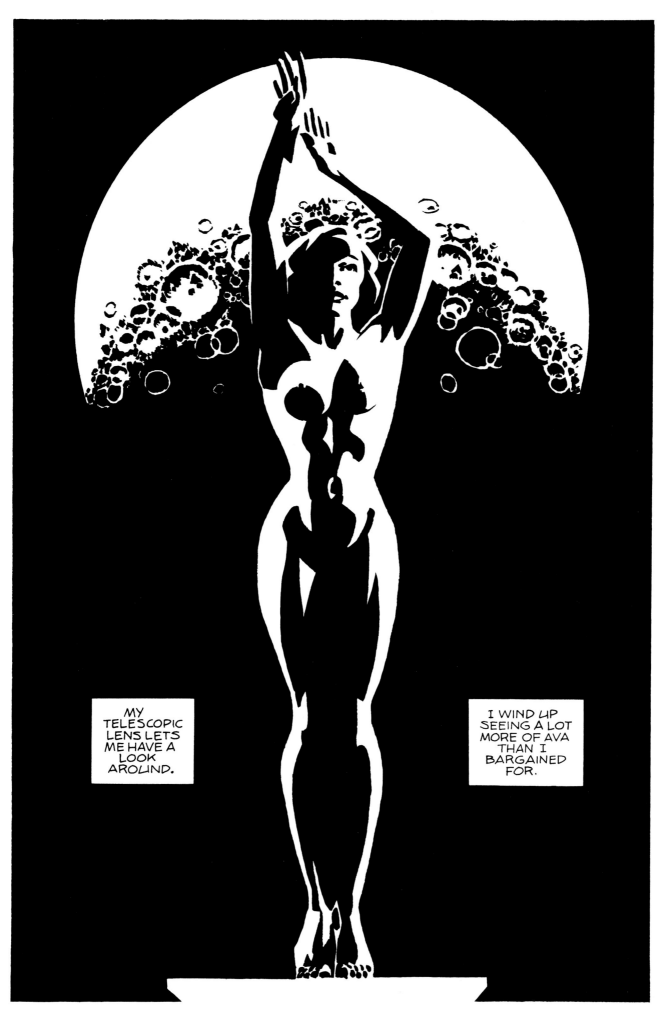

Opposite page: *Hell and Back* #1, page 14, 1999

Above: *A Dame To Kill For* #2, page 5, 1994

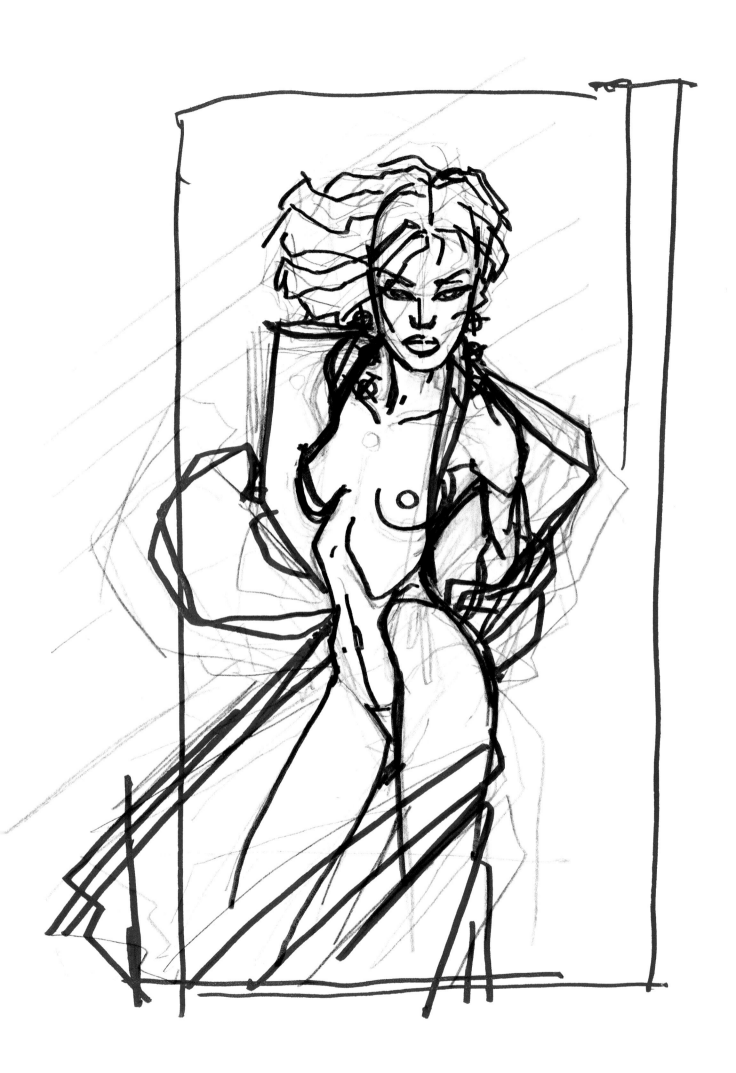

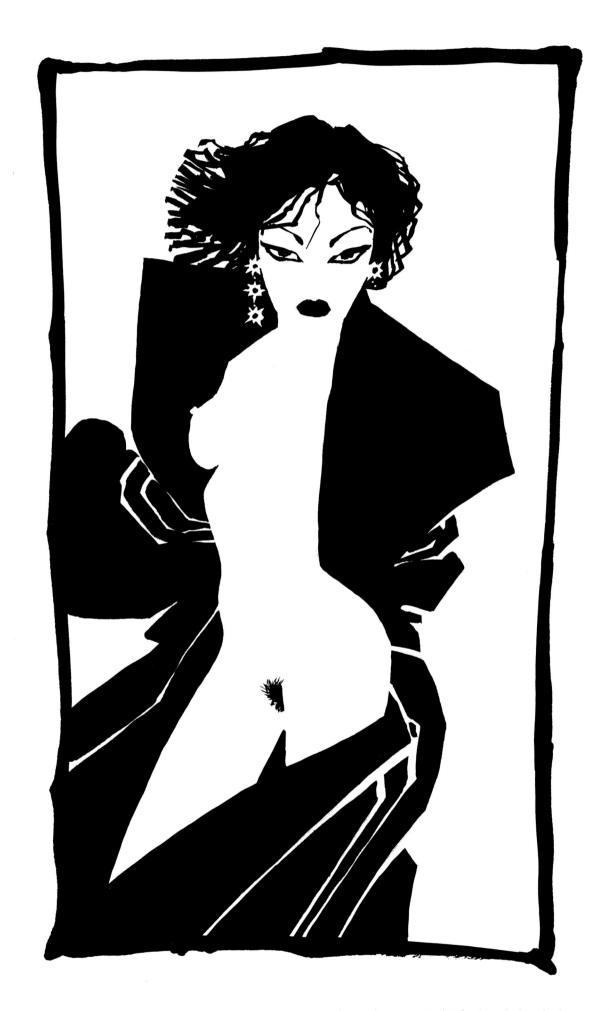

Above and opposite: *Family Values* limited edition hardcover, tip-in art, 1998

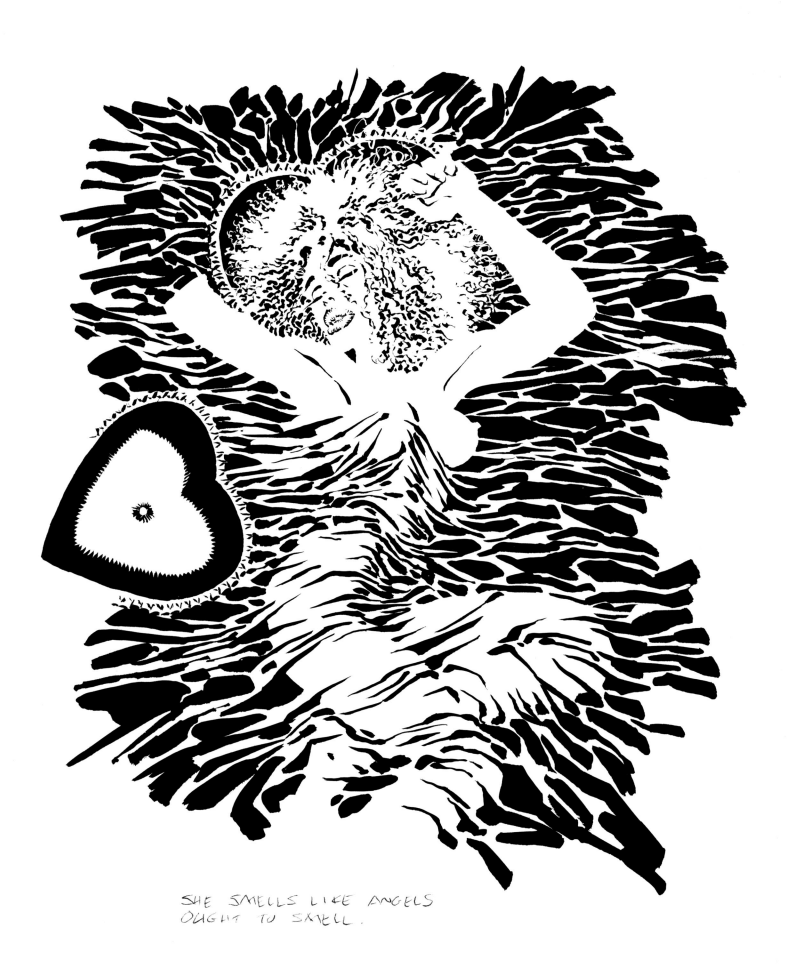

SHE SMELLS LIKE ANGELS
OUGHT TO SMELL.

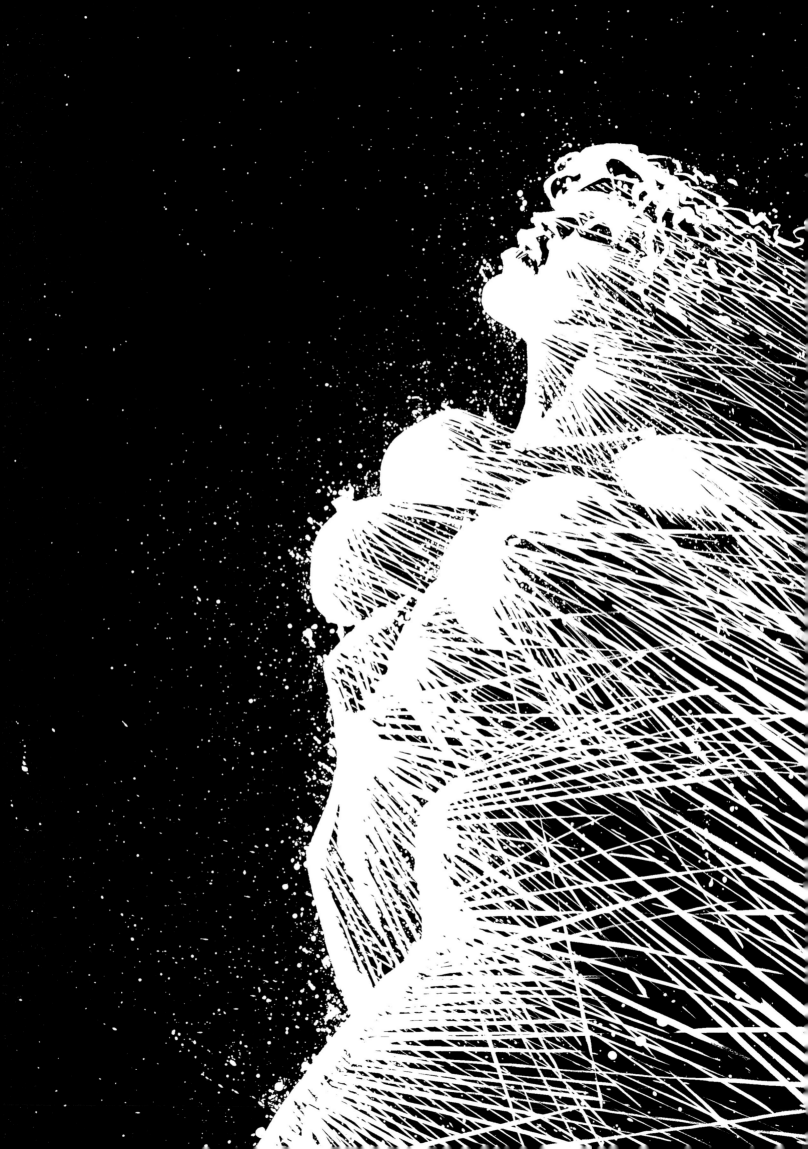

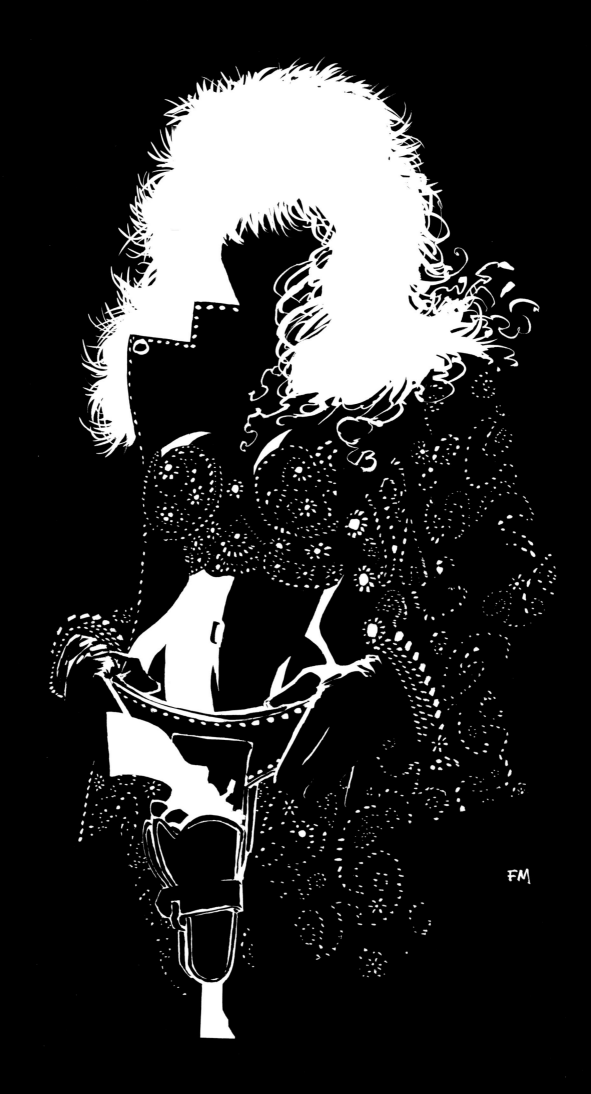

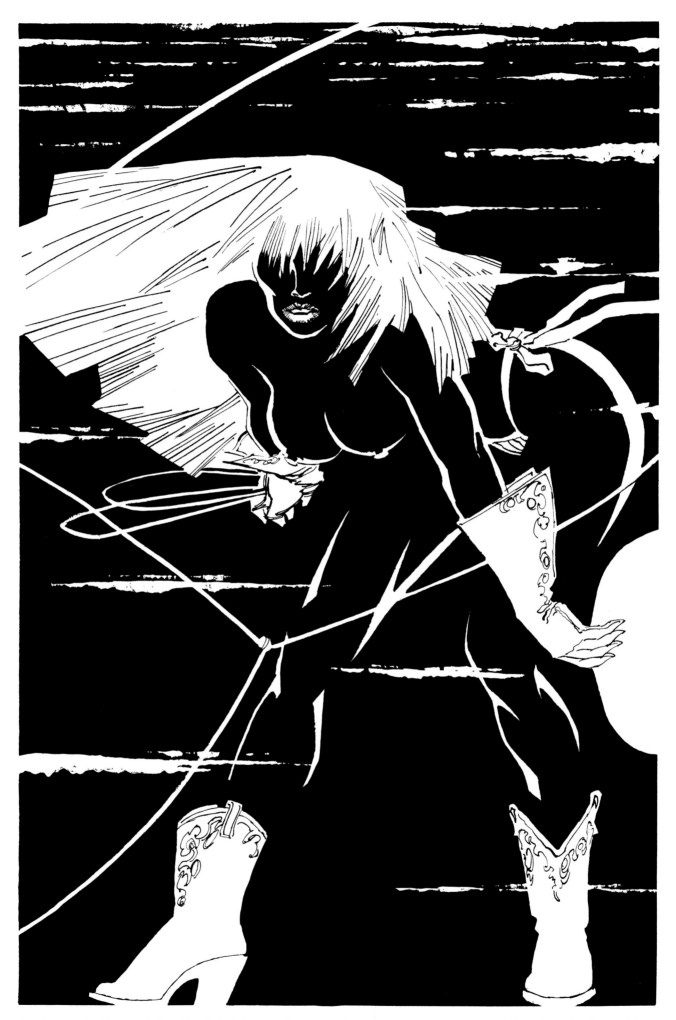

Opposite page: San Diego Comic Book Expo limited edition retailer print, 1996

Above: *A Dame To Kill For* #3, page 7, 1994

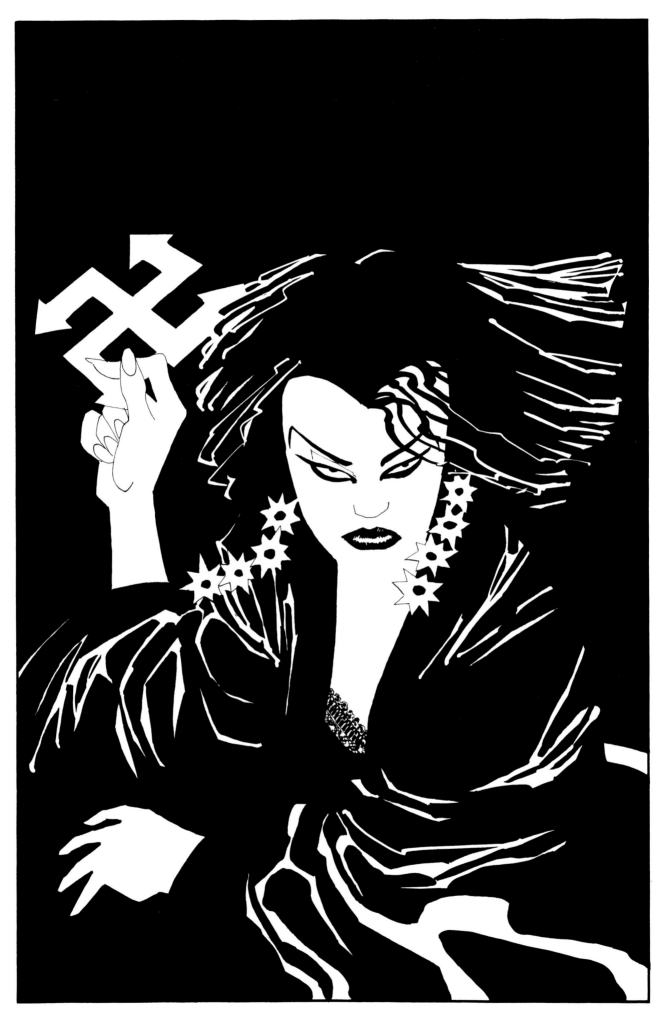

Above: *The Big Fat Kill* #2, page 6, 1994

Opposite page: *The Big Fat Kill* trade paperback, page 42, 1996

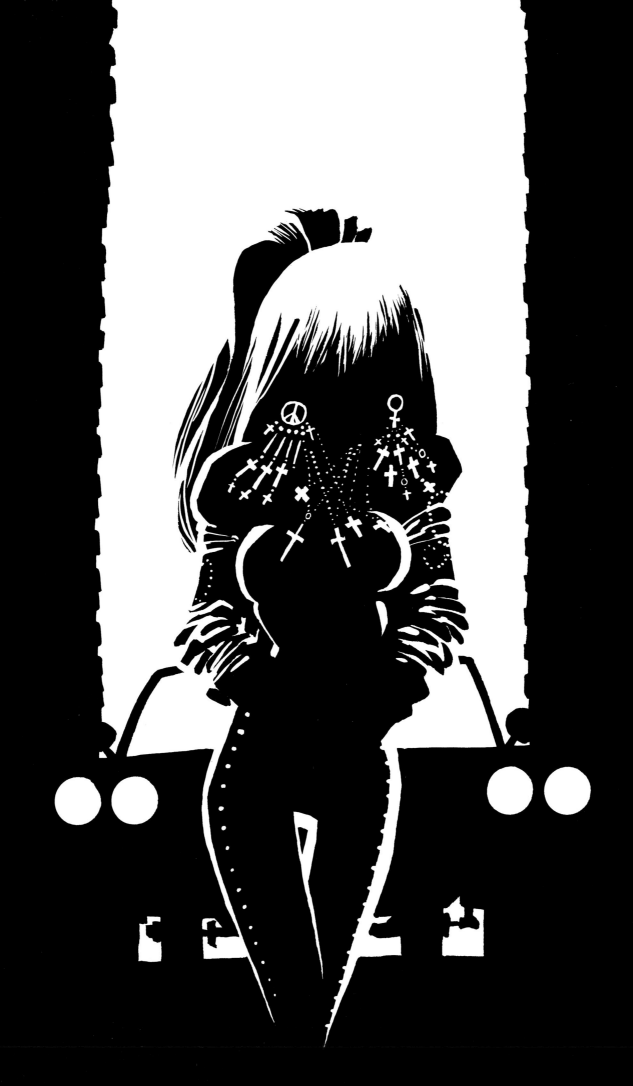

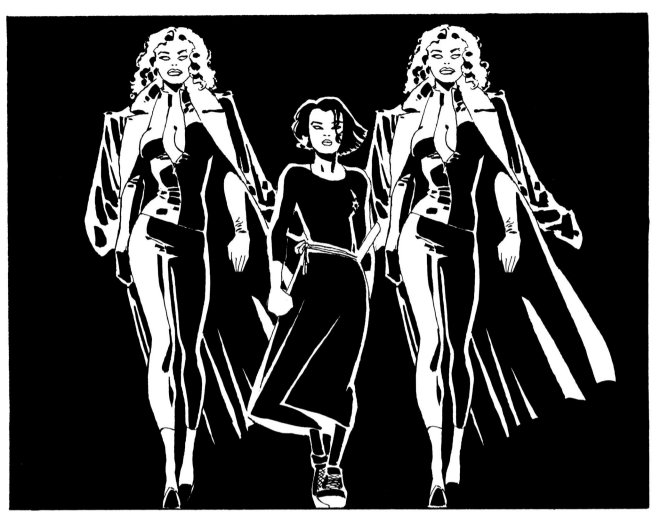

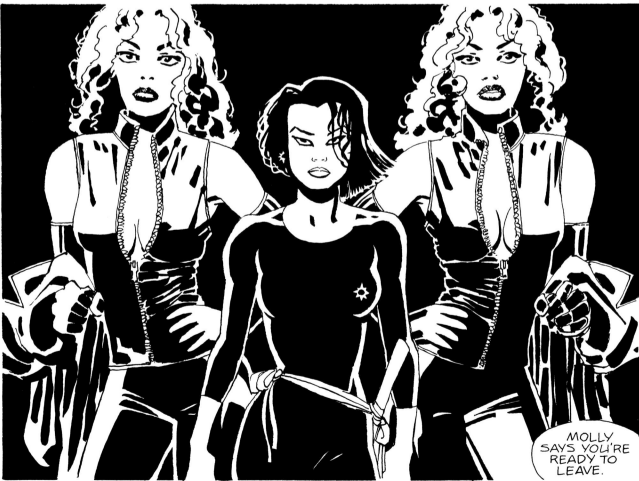

MOLLY SAYS YOU'RE READY TO LEAVE.

A Dame To Kill For #5, page 7, 1994

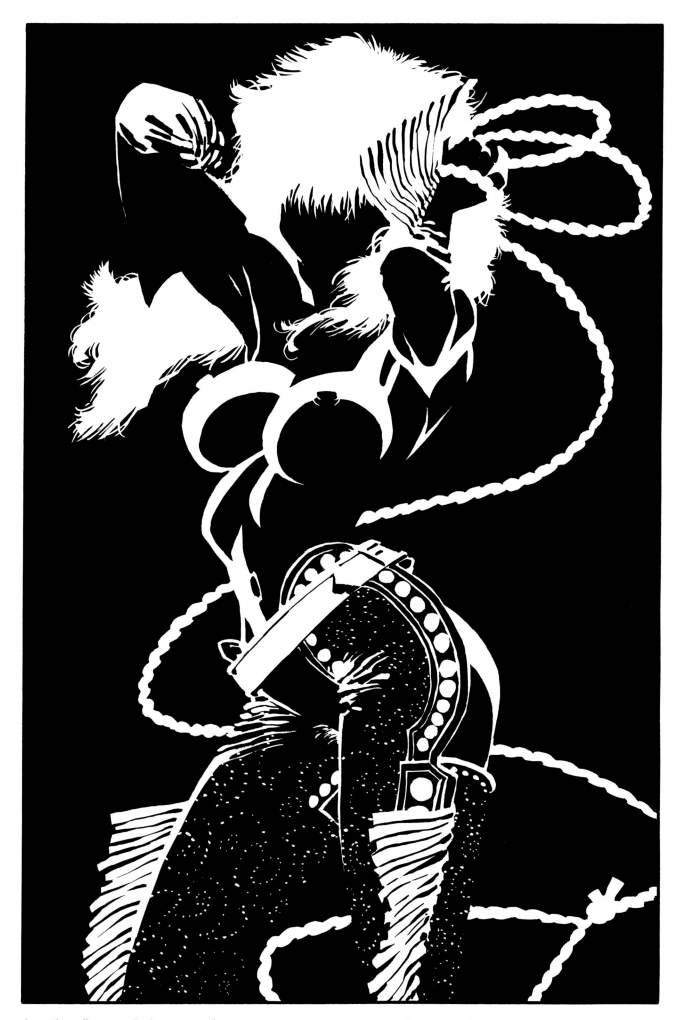

Above: *That Yellow Bastard* #4, page 27, 1996

Following page: *The Big Fat Kill* trade paperback, page 33, 1996

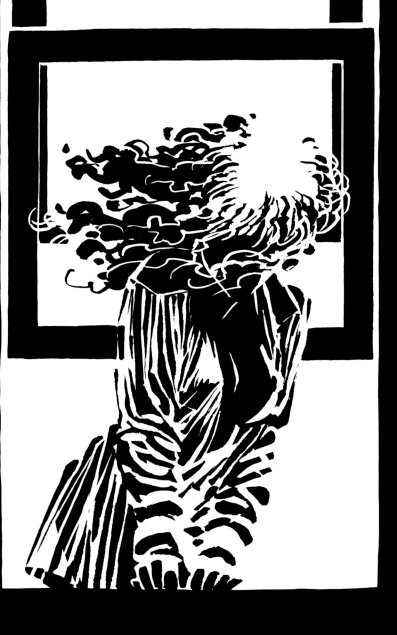

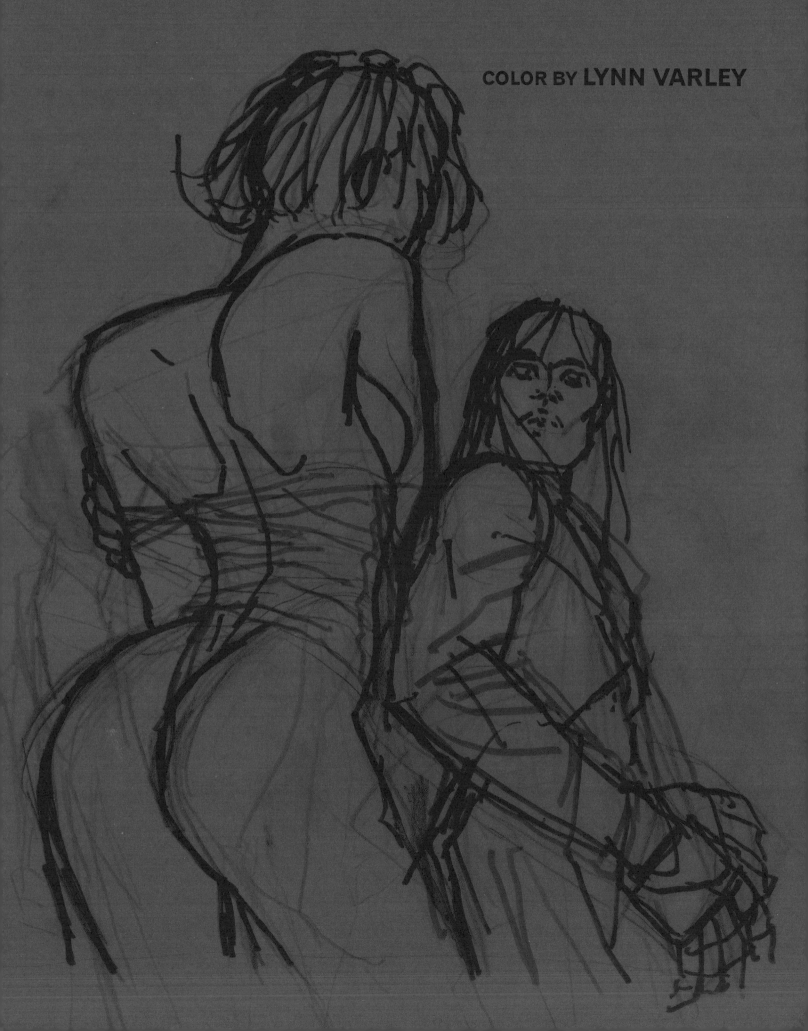

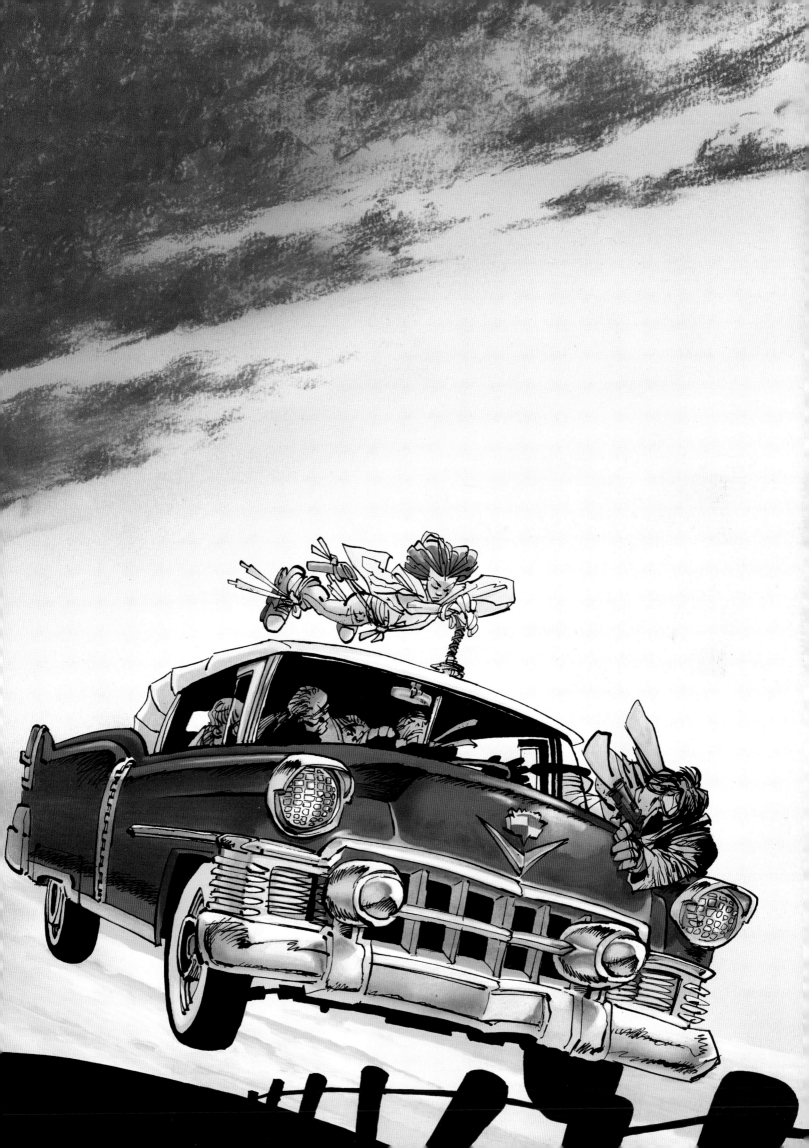

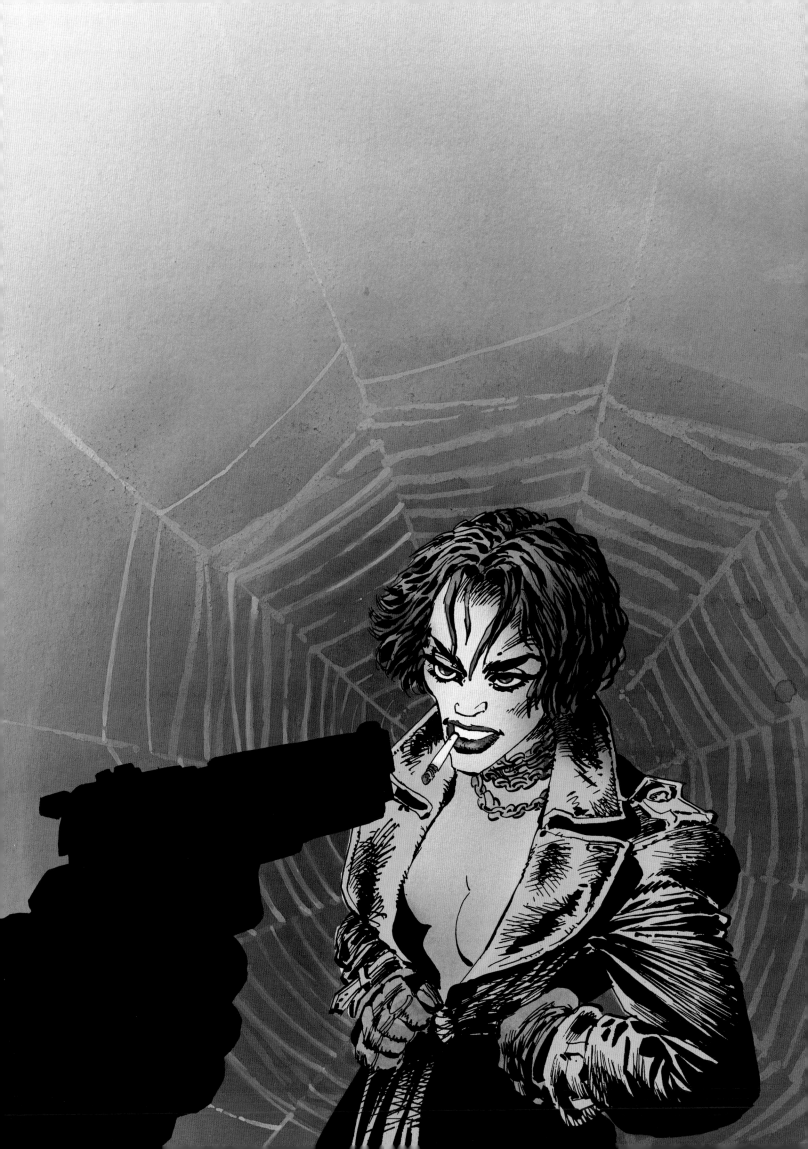

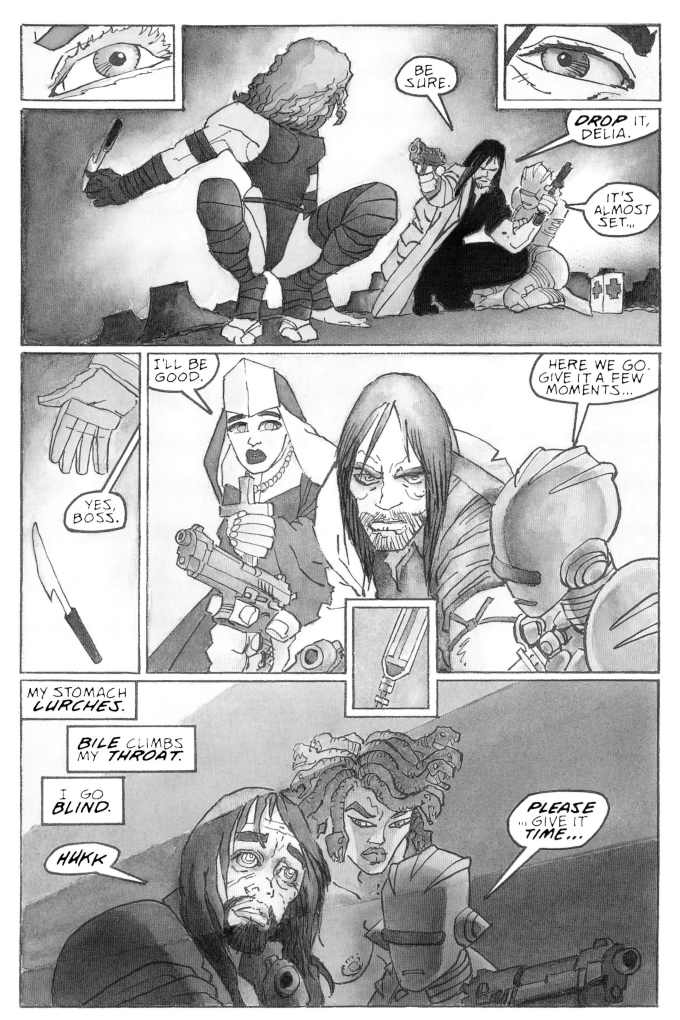

Hell and Back #7, page 25, 2000

Opposite page: *The Big Fat Kill* trade paperback, front cover, 1996

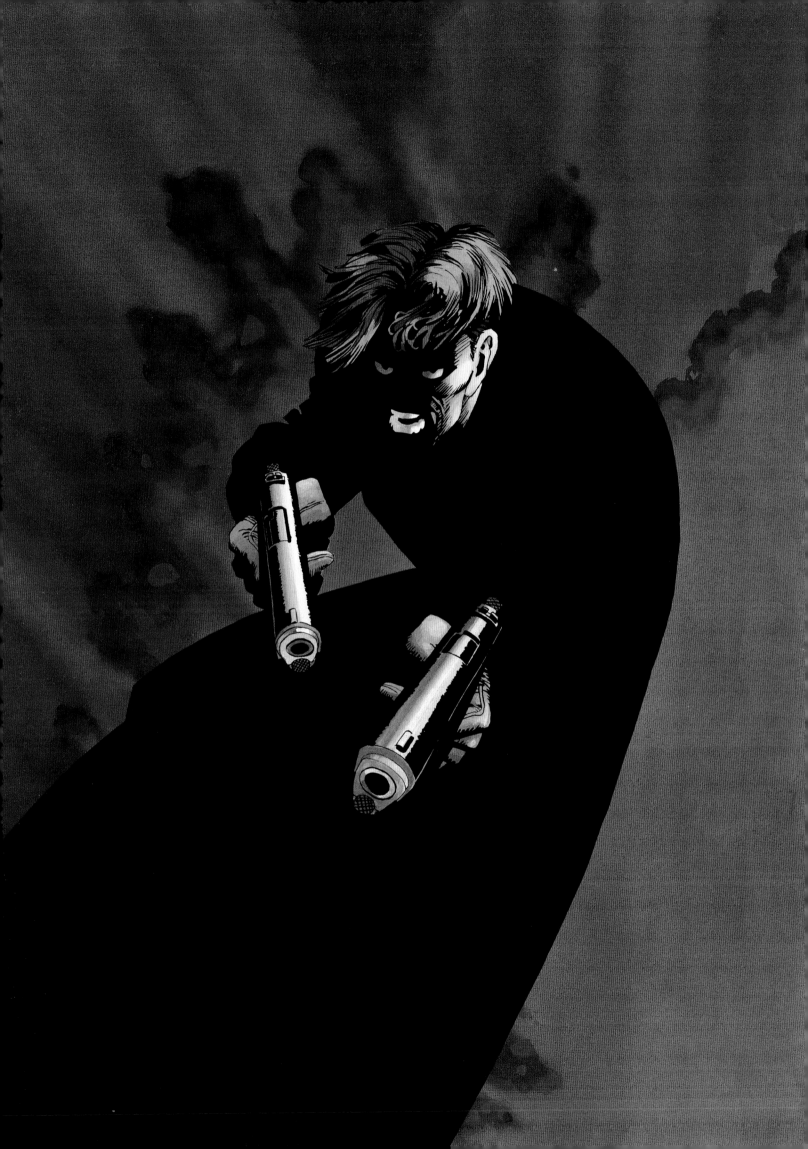

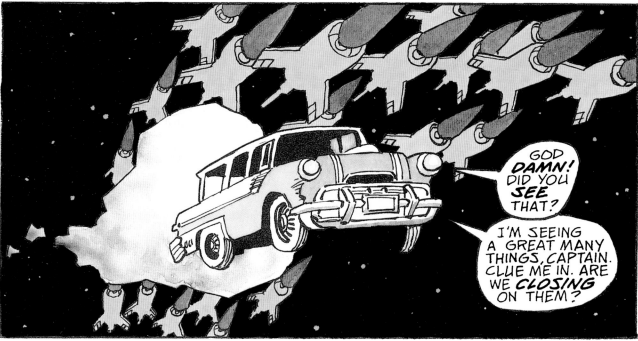

Hell and Back #7, page 20, 2000

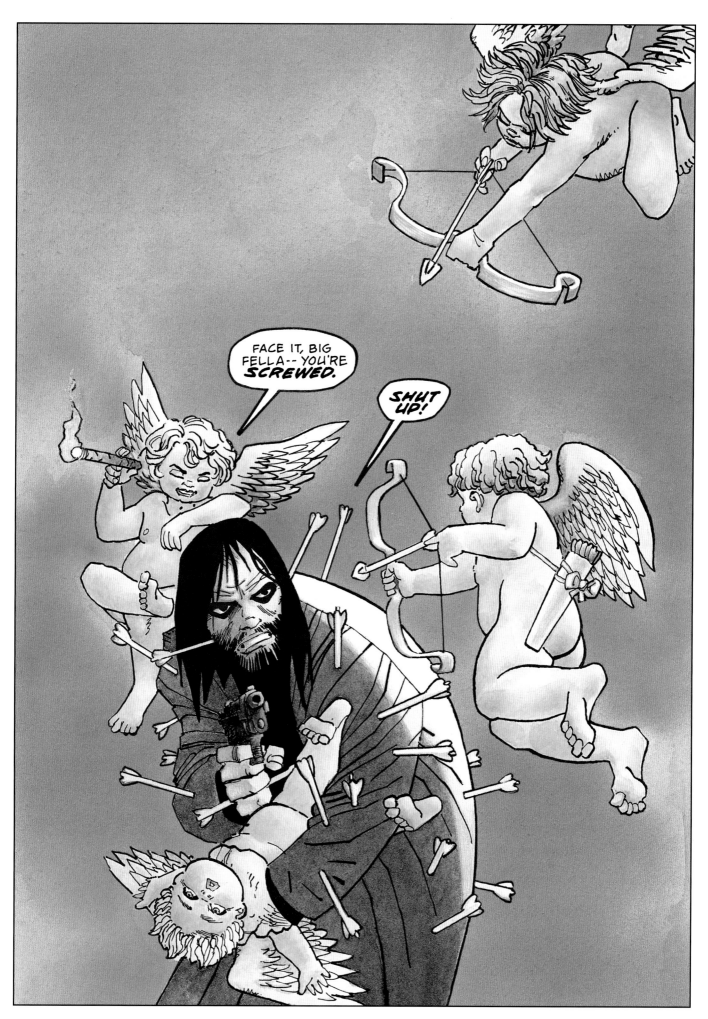

Hell and Back #7, front cover, 2000

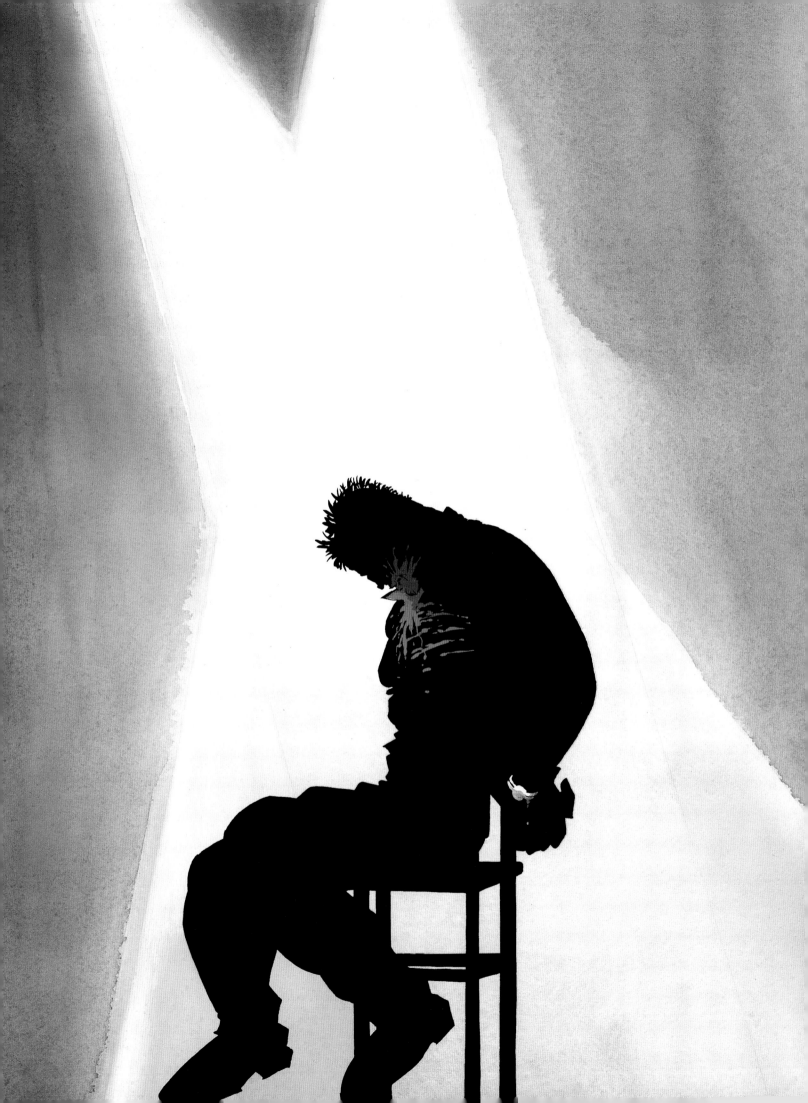

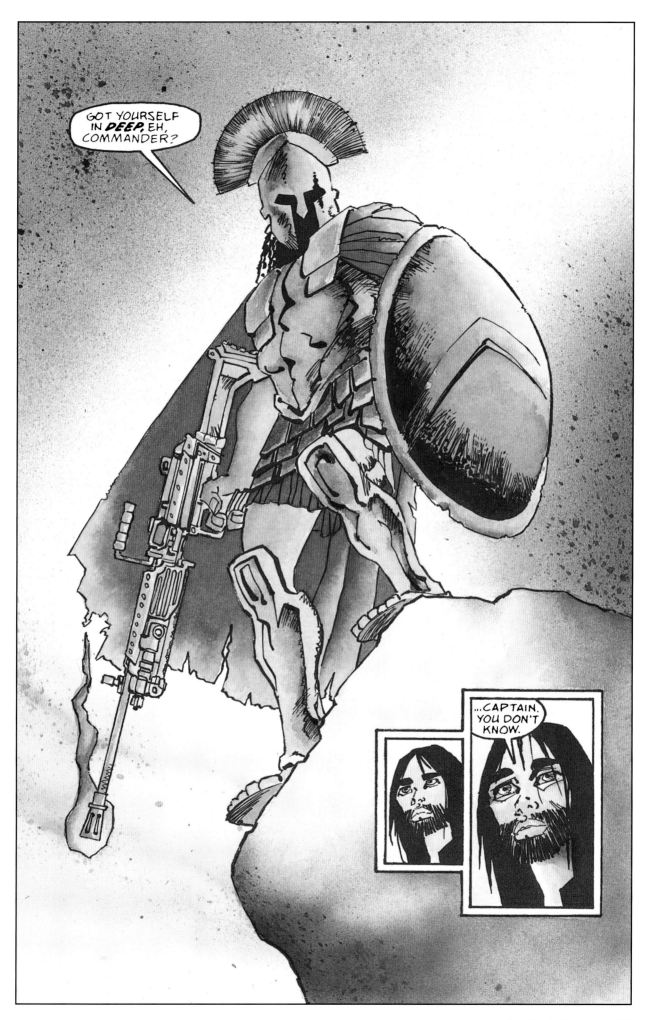

Hell and Back #7, page 14, 2000

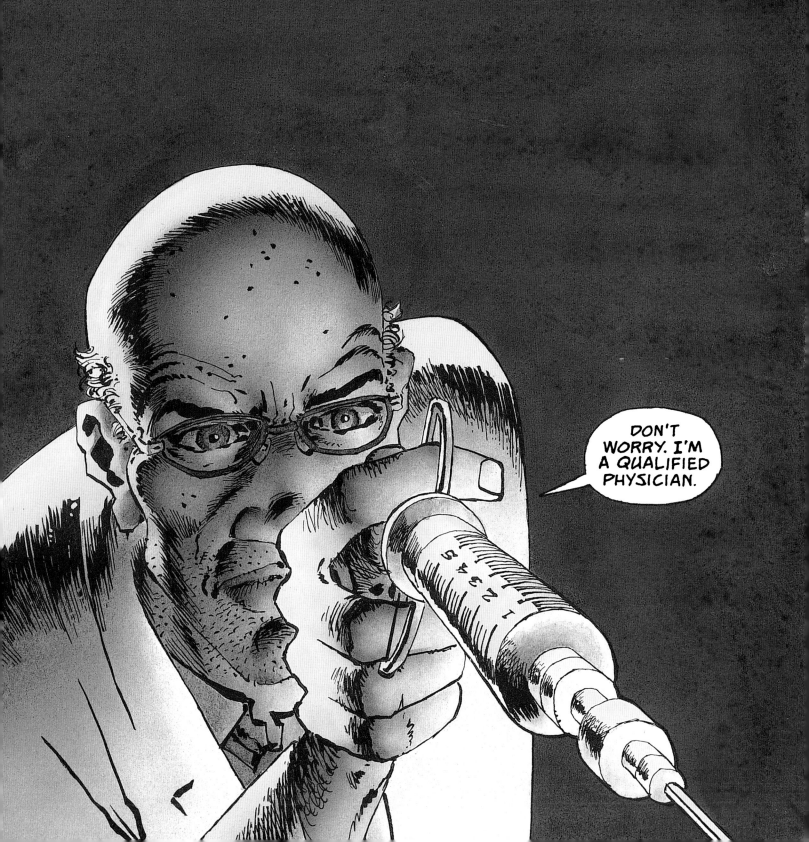

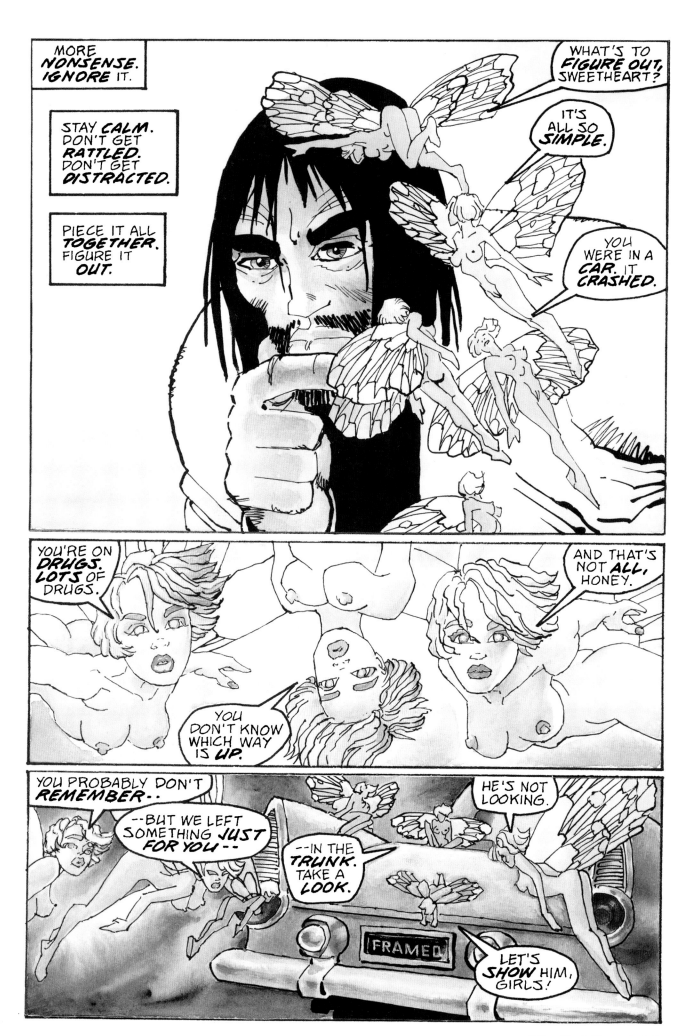

Hell and Back #7, page 9, 2000

Opposite page: *Hell and Back* #4, front cover, 1999

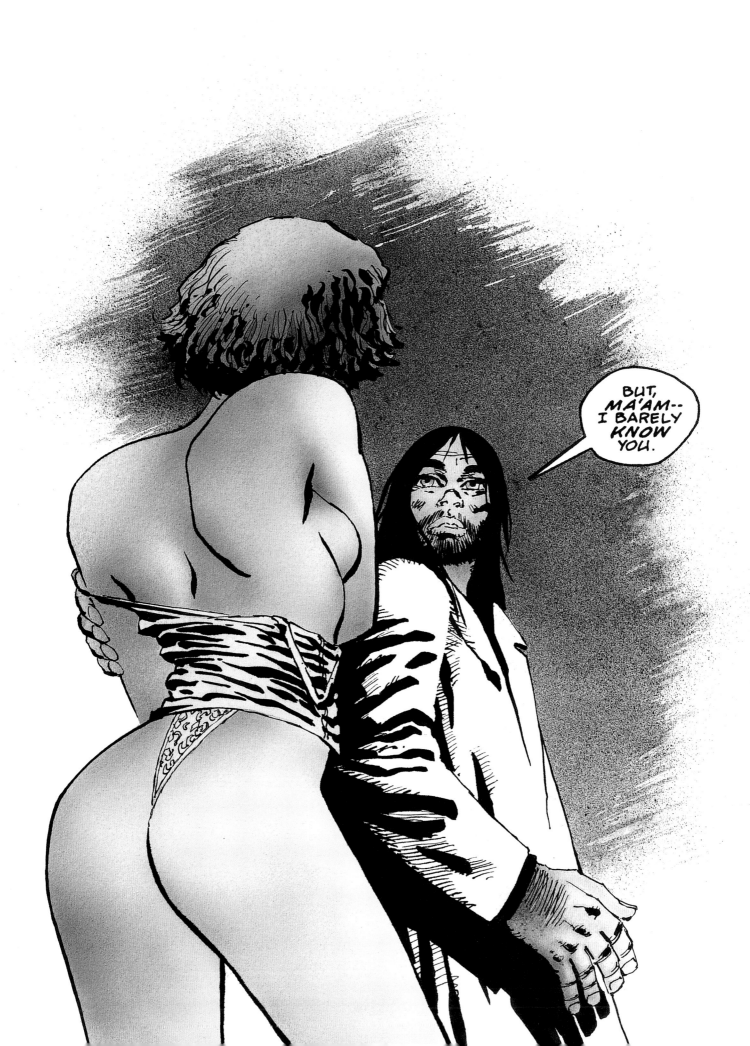

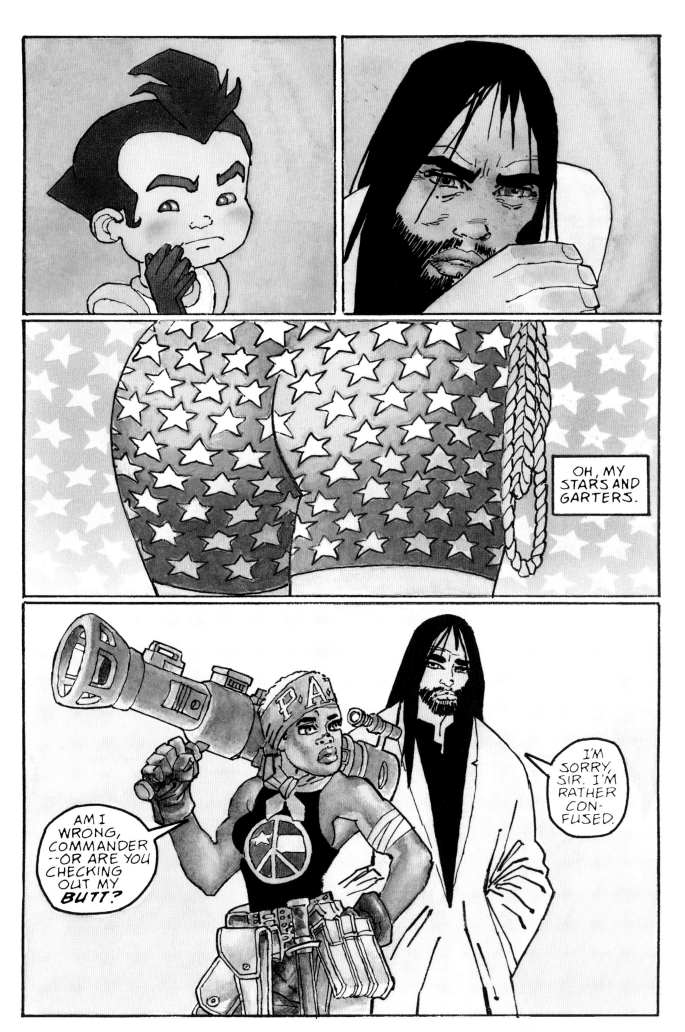

Opposite page: *Silent Night*, front cover, 1995

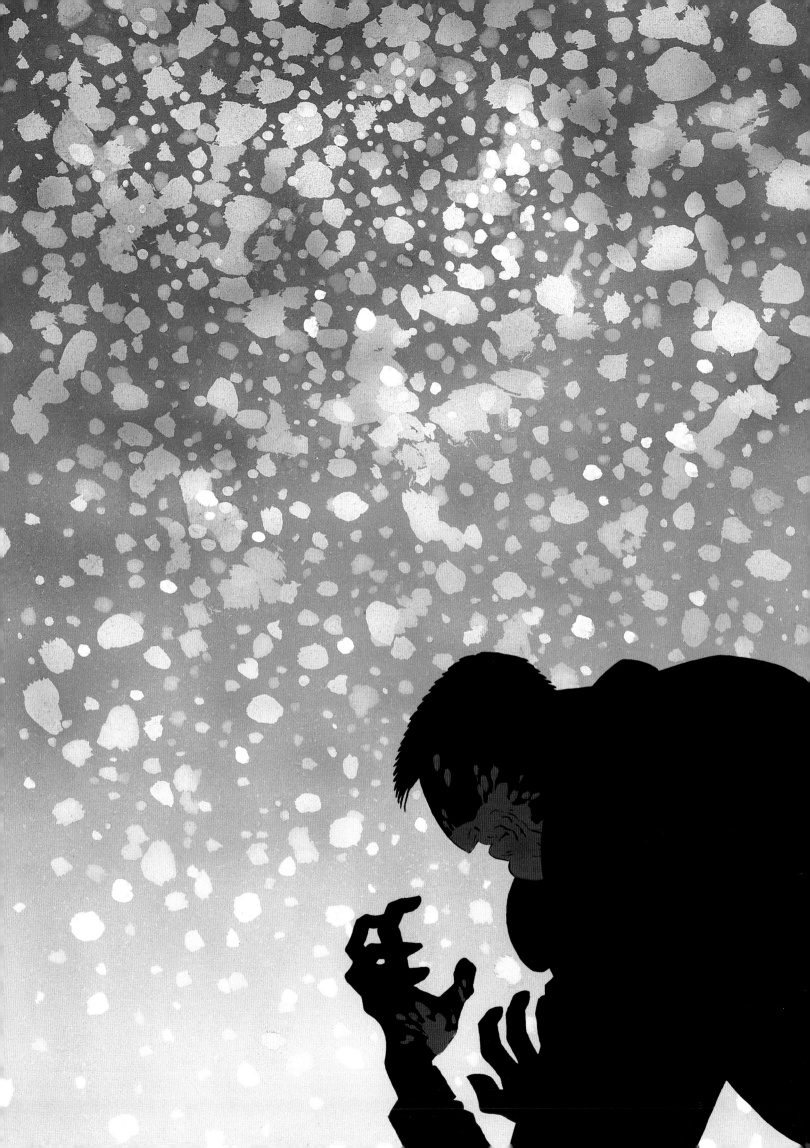

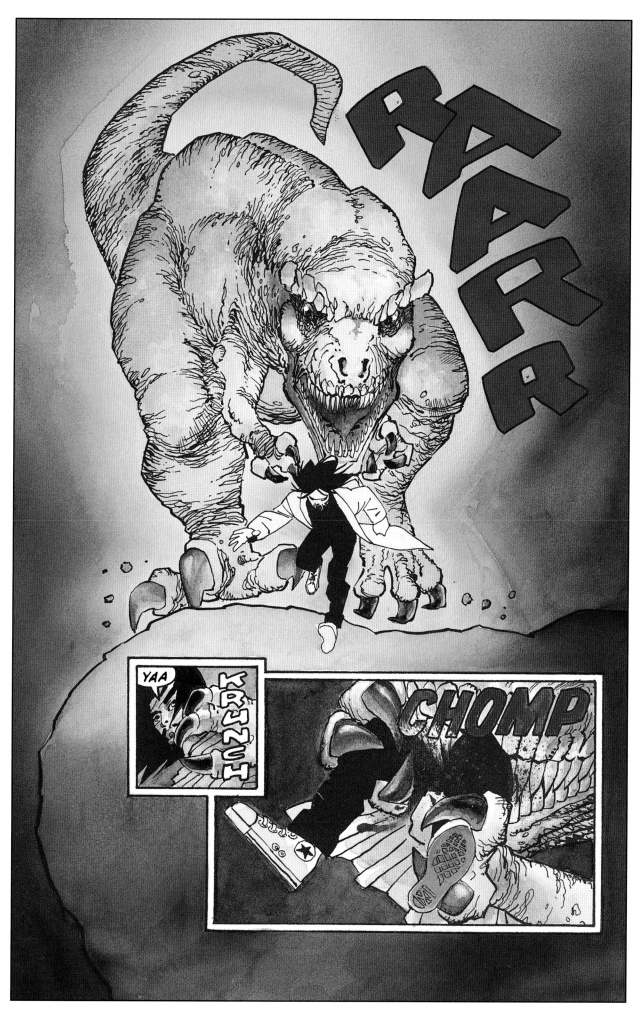

Hell and Back #7, page 6, 2000

Opposite page: *Hell and Back* #8, front cover, 2000

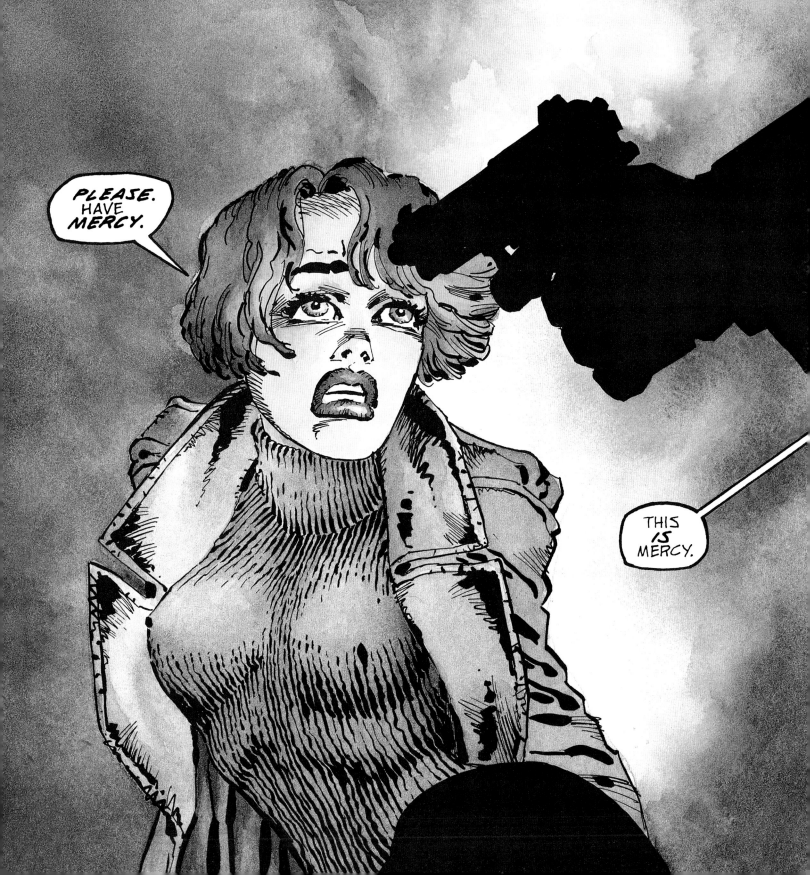